ZOO
PORTRAITS

teNeues

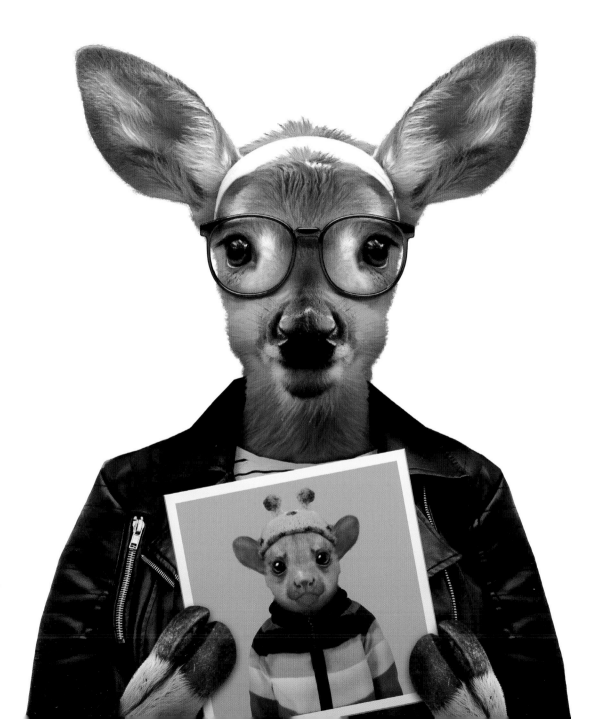

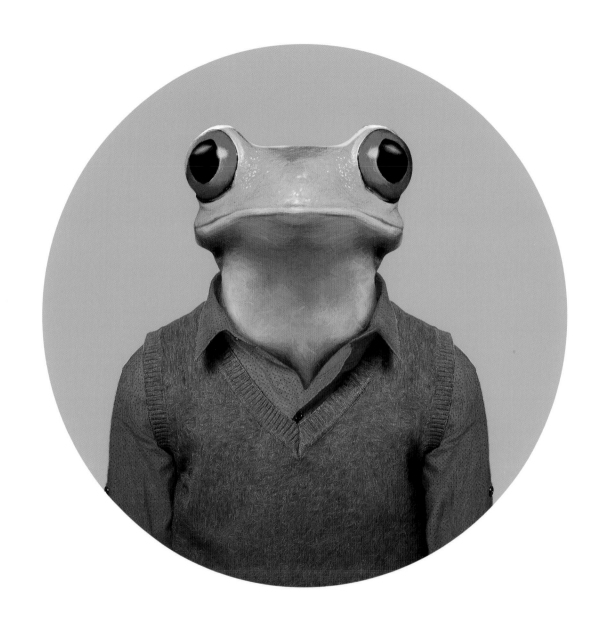

ZOO

PORTRAITS

Zoo Portraits is both a creative and educational project that focusses on the animal kingdom. It is divided into three main areas: portraits, education and awareness.

Yago Partal, a photographer in Barcelona, Spain, initially came up with the idea and began developing the project in 2013. Throughout his childhood, Yago had found himself fascinated by the animal kingdom, cartoons and fashion, all of which eventually helped him to find his voice in a game we can all take joy in: the humanization or anthropo-morphism of animals.

The project initially launched as a marketing campaign but quickly went viral, attracting the attention of the world's press, leading to several license offers and eventually to the development of a brand with the assistance of brand manager Isabelle Bazsó.

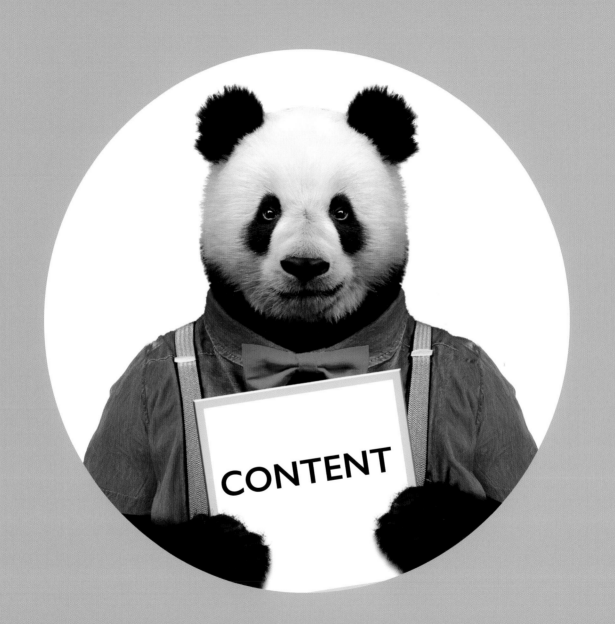

MARCO, the Goat Kid	8	
ÓTTAR, the Harbor Seal	10	
BAO, the Giant Panda	12	
DIEGO, the Peruvian Night Monkey	14	
LAURIE, the White-Tailed Deer	16	
BARUTI, the White Rhinoceros	18	
ETHAN, the American Bison	20	
MOSES, the Lion	22	
COOPER, the Koala	24	
MISHKA, the Bengal Tiger	26	
YASSER, the Veiled Chameleon	28	
NAYNA, the Cheetah	30	
AYANA, the Giraffe	32	
AARON, the Beagle	34	
JOHN, the Bald Eagle	36	
JOÃO, the Brown-Throated Sloth	38	
EVIE, the Red Fox	40	
CHANG, the Red Panda	42	
BREV, the Griffon Vulture	44	
JOSEPH, the Walrus	46	
ZAZU, the Maltese	48	
KHULAN, the Pallas's Cat	50	
HUNTER, the Tasmanian Devil	52	
BAGUS, the Asian Elephant	54	
RÉGIS, the Bongo	56	
LIAM, the American Black Bear	58	
RIKY, the Kinkajou	60	
FERNANDO, the Spanish Fighting Bull	62	
PEDRO, the European Rabbit	64	
NABILA, the Fennec Fox	66	
SAMMY, the Ostrich	68	
HENRY, the Wombat	70	
ARLO, the Common Brushtail Possum	72	
AGUNG, the Binturong	74	
OTTO, the Arctic Fox	76	

OUMAR, the Chimpanzee	78	
GOROU, the Sea Otter	80	
JEONG, the Amur Leopard	82	
AWAX, the Western Lowland Gorilla	84	
PETER, the Red Kangaroo	86	
CAMILO, the Red-Eyed Tree Frog	88	
JAMES, the Crested Black Macaque	90	
WESLEY, the Ring-Tailed Lemur	92	
BENI, the Mandrill	94	
HUI, the Golden Snub-Nosed Monkey	96	
JACOB, the Kodiak Bear	98	
ÀBAKAR, the Caracal	100	
RASCAL, the Raccoon	102	
STAN, the Aye-Aye	104	
HANI, the Giraffe Gazelle	106	
OLIVIA, the Eastern Grey Kangaroo	108	
CESAR, the Black Panther	110	
TOOH, the Southern Cassowary	112	
ALEK, the Puffin	114	
COLTON, the Gray Wolf	116	
DEE, the Ferret	118	
SAKARI, the Polar Bear	120	
ALFIE, the Little Owl	122	
TITUS, the Pygmy Hippopotamus	124	
SAIJA, the Red Squirrel	126	
EDWIN, the Emperor Tamarin	128	
RAILA, the Plains Zebra	130	
AIPERI, the Snow Leopard	132	
GABRIELA, the Tapir	134	
ATOM, the Chihuahua	136	
ABBY, the British Shorthair Cat	138	
ISABELLA, the Barn Owl	140	
ANA MARIA, the Spectacled Bear	142	
FRITZ, the Long-Eared Hedgehog	144	
YUSUF, the Bornean Orangutan	146	

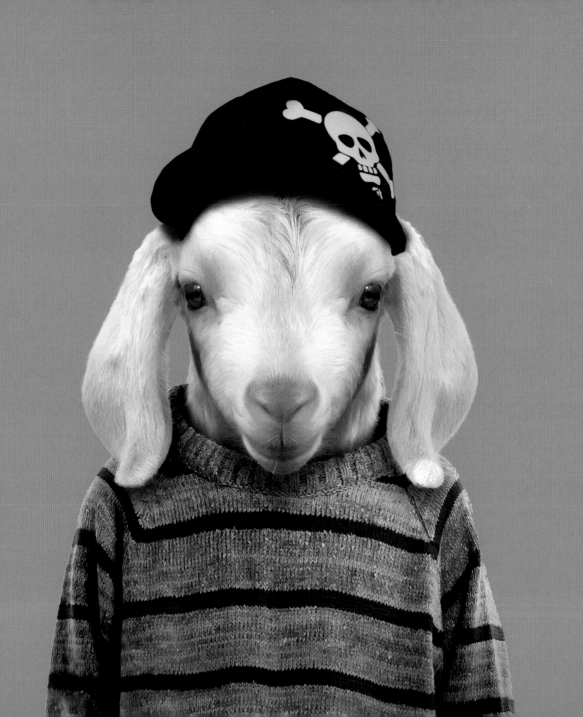

MARCO THE GOAT KID

COMMON NAME
Domestic goat

SCIENTIFIC NAME
Capra aegagrus hircus

CONSERVATION STATUS
Not Evaluated (NE)

POPULATION
Common

HABITAT
Domestic animal that also lives
in remote and inaccessible areas

SIZE / WEIGHT
⇡ 10–42 in. (26–107 cm)
▬ 45–300 lb. (20–140 kg)

GESTATION PERIOD
150 days

DIET
Variety of plants, some of which grow
in areas that are difficult to access

LIFE SPAN
15–18 years

DID YOU KNOW...

Domestic goats are descendents of wild goats originally living in South Asia and Eastern Europe. Goats were presumably the first animals to be domesticated by humans, around 10,000 years ago. Today, there are more than 300 different breeds and over 920 million goats living all over the world. Young goats are known as kids, females as does, males are bucks, and castrated males are called wethers. Goats are ruminants, which means that they have four-chambered stomachs for digestion. These chambers are called the rumen, reticulum, omasum, and abomasum. They also have cloven hooves, which make these agile and resilient animals capable of scaling steep cliffs—and also, therefore, of living in relatively inhospitable regions. Goats also have outstanding memories. They are able to solve complex problems and to remember the solutions ten months later. They can bleat in a variety of accents, which differ from group to group and help them identify each other.

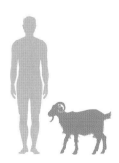

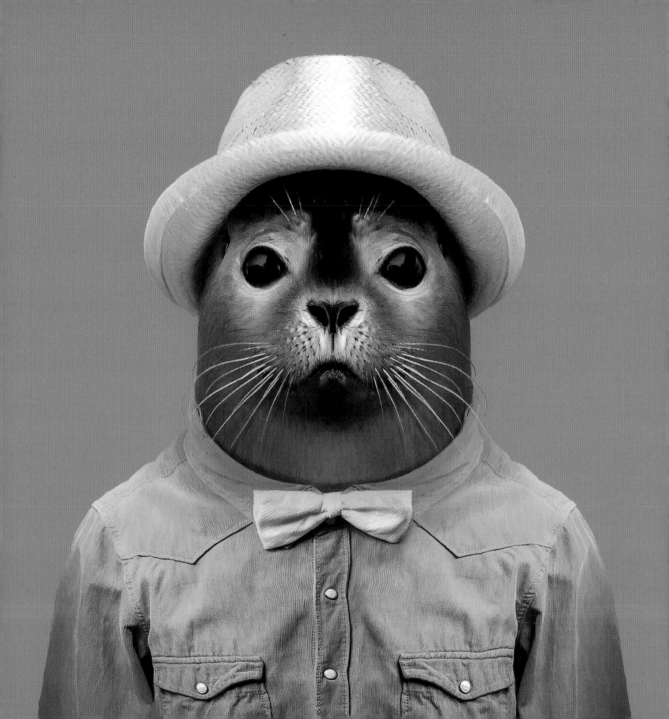

ÓTTAR THE HARBOR SEAL

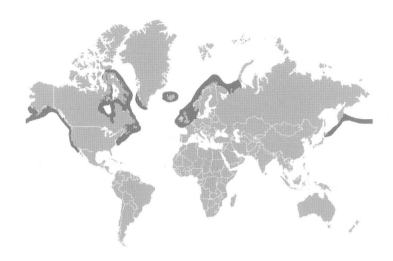

DID YOU KNOW...

Biologically speaking, harbor seals are descended from dogs and bears, whose front and hind legs mutated to become flippers. Harbor seals' front flippers are used underwater for steering, while their back flippers propel them along. Although harbor seals are extremely clumsy on land, they can dive under water to a depth of 1578 ft. (481 m) for up to 35 minutes at a time. Before diving, they expel all the air from their lungs. They then use their blood oxygen under water (they have higher relative blood volumes than other animals). They can also lower their heart rate from 100 to 10 beats per minute, thereby conserving oxygen. Once back at the surface, they refill their lungs to 90% of their capacity with a single breath. They are aided in hunting fish by their long facial whiskers, which help them locate their prey, and by their large eyes, which enable them to spot their quarry in the dark depths. Baby harbor seals are raised on their mothers' milk, which has a fat content of 40%, and can survive on their own at just one month old.

COMMON NAME
Harbor seal

SCIENTIFIC NAME
Phoca vitulina

CONSERVATION STATUS
Least Concern (LC)

POPULATION
350,000–500,000 individuals

HABITAT
Temperate coastal waters and cold oceans in the Northern Hemisphere

SIZE / WEIGHT
⇨ ♀ 3.9–5.6 ft. (1.2–1.7 m)
⇨ ♂ 4.6–6.2 ft. (1.4–1.9 m)
🏋 ♀ 99–231 lb. (45–105 kg)
🏋 ♂ 121–375 lb. (55–170 kg)

GESTATION PERIOD
315–330 days (delayed implantation)

DIET
Primarily fish, occasionally mollusks, crabs, and squid

LIFE SPAN
20–35 years

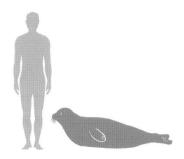

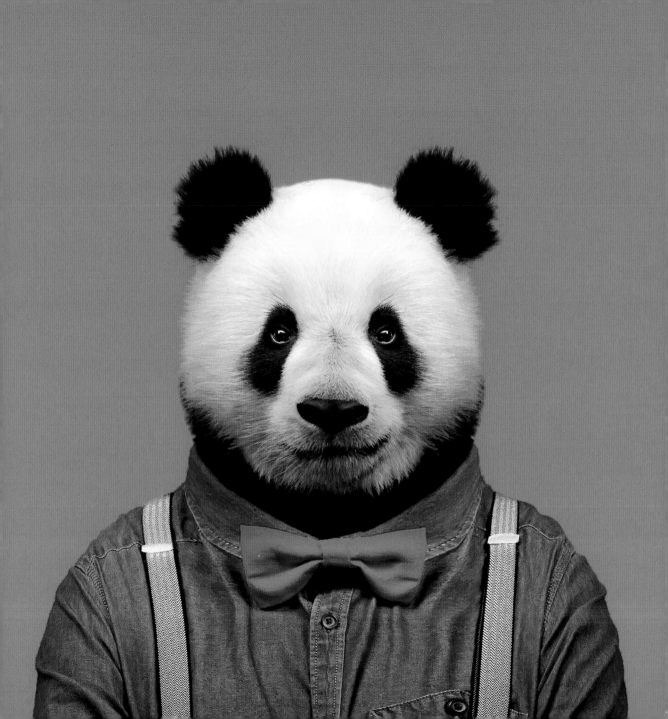

BAO THE GIANT PANDA

DID YOU KNOW...

Since their diet consists mainly of bamboo, giant pandas do not build a layer of fat and therefore do not hibernate like other types of bears. Although their powerful molars enable them to chew bamboo branches, their digestive systems are similar to those of carnivores, which makes it difficult for them to digest the bamboo. As a result, they excrete around 44 lb. (20 kg) of indigestible material per day. Giant pandas are solitary, except for cubs, who live with their mothers for about 2 years. Despite their cuddly appearance, pandas are exceptionally aggressive and dangerous, especially when they feel threatened. Poachers and habitat loss are the reasons that they are an endangered species, and the fact that females are only fertile for a single 2–3-day period once a year does not help matters. For the Chinese, these animals are a symbol of yin and yang, thanks to their black and white markings. Until 1997, hunting giant pandas in China was punishable by death. Now, the penalty is "only" 20 years in prison.

COMMON NAME
Giant panda

SCIENTIFIC NAME
Ailuropoda melanoleuca

CONSERVATION STATUS
Vulnerable (VU)

POPULATION
1,864 individuals in the wild
in the year 2013

HABITAT
Mountain forests with bamboo

SIZE / WEIGHT
⇡ 1.9–3 ft. (0.6–0.9 m)
⇨ 3.9–5.9 ft. (1.2–1.8 m)
⚖ 154.3–275.6 lb. (70–125 kg)

GESTATION PERIOD
95–146 days (delayed implantation)

DIET
99% of their diet is bamboo
(30 varieties)

LIFE SPAN
12–20 years

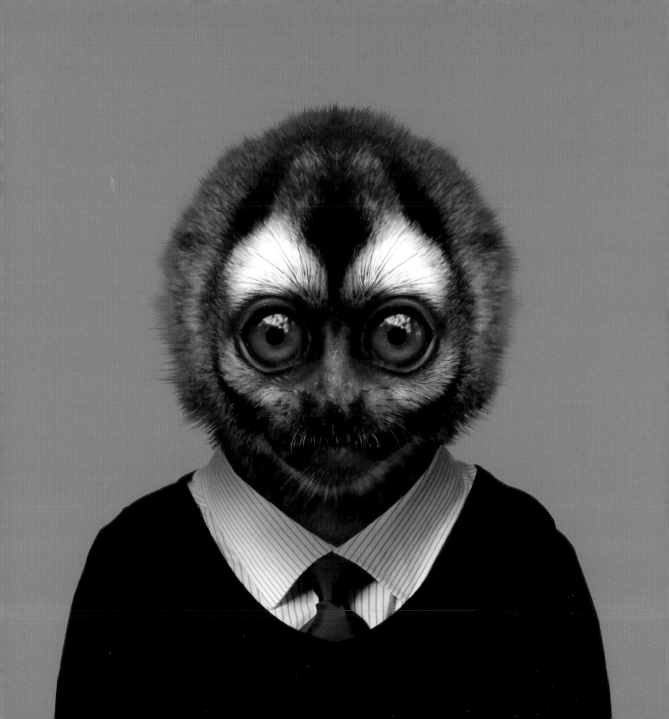

DIEGO THE PERUVIAN NIGHT MONKEY

DID YOU KNOW...

There are eleven species of night monkey, which can be divided into two sub-groups according to the color of their throat or chest (red or gray). Of all these species, the Peruvian night monkey, with its gray fur and glowing orange chest, is the most threatened. It is also the species least studied by science. What do we know about them? Night monkeys are exclusively tree dwellers, moving around the branches using their long tails for balance. As their name suggests, they are active at night and, perhaps due to this, are the only New World monkeys (species native to Central and South America and parts of Mexico) with limited color vision. Their extremely large eyes support their night vision, while their ears are comparatively tiny. They are monogamous, have just one baby per year, and live in family groups of between two and six members in their own territories, which they delineate using scent marks and defend with loud screeches. They can, however, also communicate using other sounds, including growls, trills, moans, hoots, and squeaks. Mothers take care of their babies for approximately their first week of life, and then hand them off to the fathers for the rest of their upbringing.

COMMON NAME
Peruvian night monkey or
Peruvian owl monkey

SCIENTIFIC NAME
Aotus miconax

CONSERVATION STATUS
Vulnerable (VU)

POPULATION
Unknown

HABITAT
Cloud forests at altitudes
of 3,000–9,200 ft. (900–2,800 m)

SIZE / WEIGHT
⇧ 20 in. (50 cm)
⚖ 1.5–2.6 lb. (0.7–1.2 kg)

GESTATION PERIOD
133–141 days

DIET
Mainly fruit, but also eat leaves,
shoots, and insects

LIFE SPAN
11–20 years

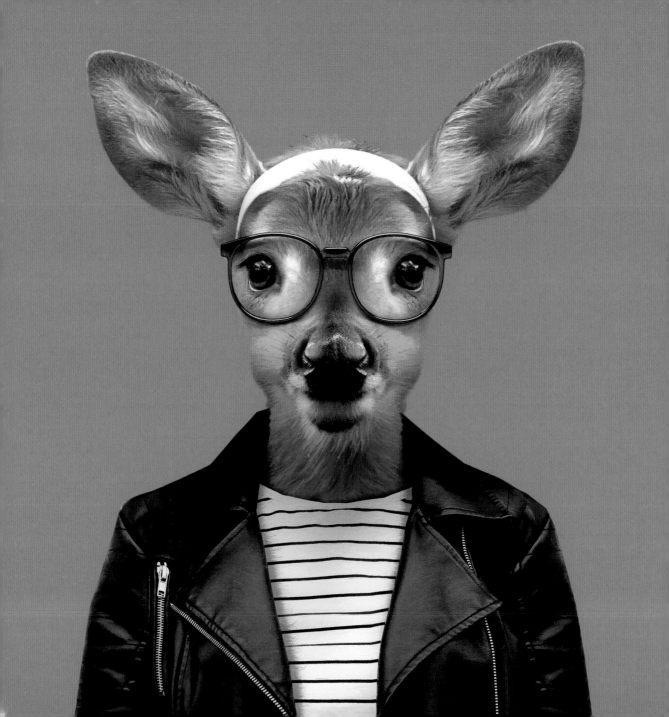

LAURIE THE WHITE-TAILED DEER

DID YOU KNOW...

There are considerable physical differences between male and female white-tailed deer: Not only are the males larger than the females, but they also have antlers that they shed every winter. In spring, their antlers regrow with incredible speed (around 1 inch, or 2.5 cm, per day). Due to their high calcium content, the shed antlers are eagerly eaten by rodents and other small animals. The stags battle each other for dominance during the mating season. White-tailed deer are ruminants with four stomachs. This enables them to digest their food (which includes plants and fungi, even poisonous varieties) more effectively. White-tailed deer have very highly developed senses of smell and hearing, as well as excellent night vision. If they sense danger, they lift their tails, snort, and stamp their hooves in order to warn the other members of the herd before taking flight. They can leap as far as 24.6 ft. (7.5 m) in a single bounding stride, which allows them to reach running speeds of up to 40 mph (65 km/h). They are also good swimmers. In the wild, they have a life expectancy of just five years, but can live to the age of 20 in captivity.

COMMON NAME
White-tailed deer

SCIENTIFIC NAME
Odocoileus virginianus

CONSERVATION STATUS
Least Concern (LC)

POPULATION
Common

HABITAT
Forests, wetlands, scrubland, prairies, semideserts

SIZE / WEIGHT
⇡ 21–42 in. (53–120 cm)
♀ 88–198 lb. (40–90 kg)
♂ 100–400 lb. (45–180 kg)

GESTATION PERIOD
200–205 days

DIET
Various plants found in their native environment

LIFE SPAN
6–14 years

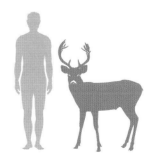

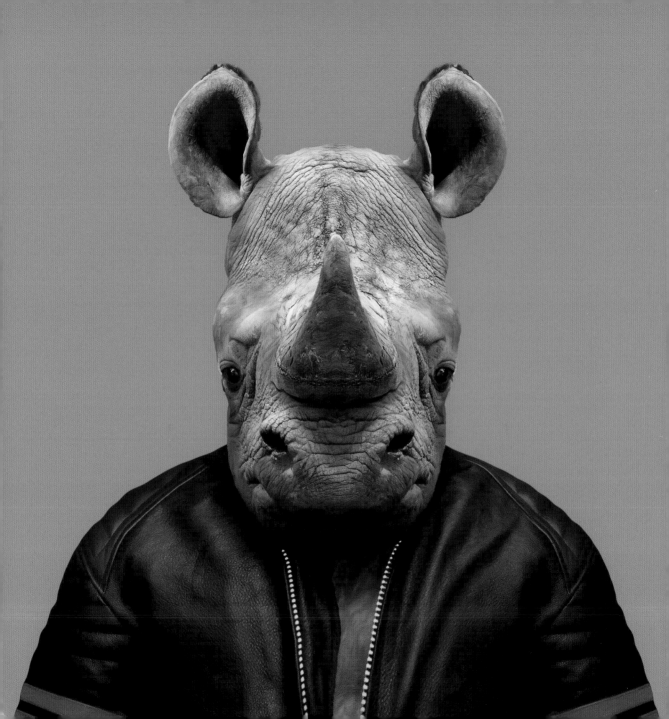

BARUTI THE WHITE RHINOCEROS

COMMON NAME
White rhinoceros

SCIENTIFIC NAME
Ceratotherium simum

CONSERVATION STATUS
Near Threatened (NT)

POPULATION
20,000 individuals

HABITAT
African savanna

SIZE / WEIGHT
⇧ 5.3–6.2 ft. (1.6–1.9 m)
⇨ 11.2–13.1 ft. (3.4–4 m)
🏋 ♀ 3,700 lb. (1,700 kg)
🏋 ♂ 5,100 lb. (2,300 kg)

GESTATION PERIOD
530–550 days

DIET
Grass

LIFE SPAN
Up to 50 years

DID YOU KNOW...

After elephants, rhinoceroses are the second-largest land mammals in the world, and are among the world's oldest species. As their names suggest, white, or square-lipped, rhinos differ from hook-lipped (black) rhinos in the shape of their mouths. White rhinos are also larger and have humps of muscle on their backs to support the weight of their large heads. Despite their massive bulk, rhinos can run at speeds of up to 24.8 mph (40 km/h) over short distances. Strong, adult males are solitary animals, except during the mating season, which they spend in herds of approximately 14 members. The females live mainly in small groups or herds with weaker males. All rhinoceroses have poor eyesight, which is balanced out by their very keen senses of hearing and smell. As rhinoceroses are herbivores, they have no incisors, only premolars and molars with grinding surfaces. Their horns are, unfortunately, the reason for their dangerous decline, which is due to poaching. Although they are made of keratin, the same substance that makes up our hair and nails, rhinoceros horns are reputed to possess magical healing powers. In fact, rhinos use their horns to defend themselves and to attract females for mating.

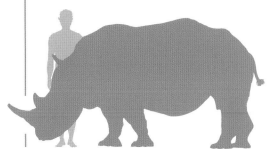

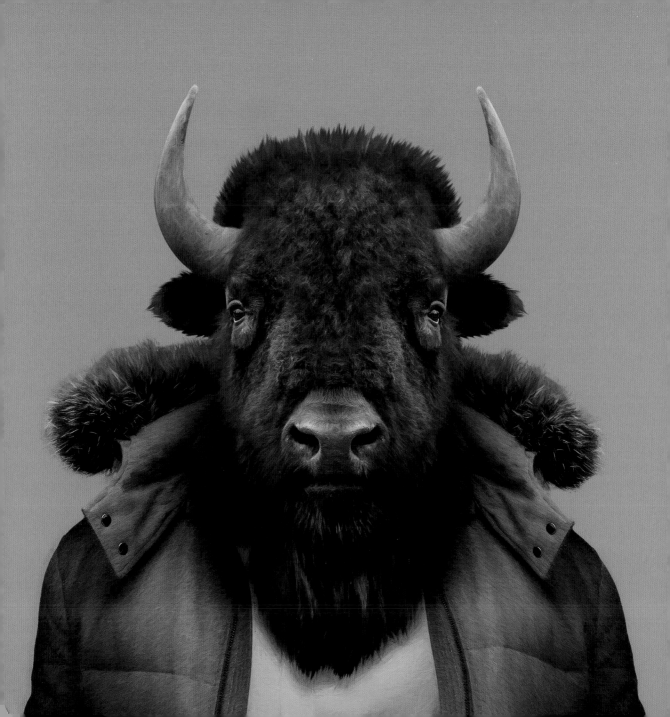

ETHAN THE AMERICAN BISON

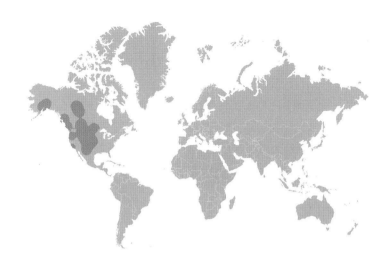

DID YOU KNOW...

The American bison, or buffalo, is America's largest land mammal, and was once on the brink of extinction. Until the mid-19th century, an estimated 40–60 million bison inhabited (primarily North) America. During the second half of the 19th century, however, they were hunted intensively by the American military in order to deprive the Native Americans, who used bison meat, bones, fat, and fur, of the basis of their existence. There are even accounts of mass slaughters being carried out purely for fun. In 1890, there were just 50 free-roaming bison living in Yellowstone National Park. Today, thanks to the intervention of private individuals and (later) the state, there are once more around 500,000 bison in America, 30,000 of which live in the wild. In their natural environment, bison live in large, hierarchical herds, led by a lead bull. Adolescent bulls leave the herd at the age of three, returning only to mate. Bison herds do not remain in one place; instead, they migrate according to the season and the vegetation available, a behavior that also prevents soil exhaustion.

COMMON NAME
American bison (buffalo)

SCIENTIFIC NAME
Bos bison

CONSERVATION STATUS
Near Threatened (NT)

POPULATION
500,000 (commercial)
30,000 (in the wild)

HABITAT
Open grasslands of the
North American prairie

SIZE / WEIGHT
⇧ 5–6.1 ft. (1.52–1.86 m)
⇨ 7–12.4 ft. (2.13–3.8 m)
🏋 ♀ 1,102 lb. (500 kg)
🏋 ♂ 1,763–2,425 lb. (800–1,100 kg)

GESTATION PERIOD
270–283 days

DIET
Grass

LIFE SPAN
Up to 15 years

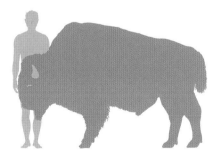

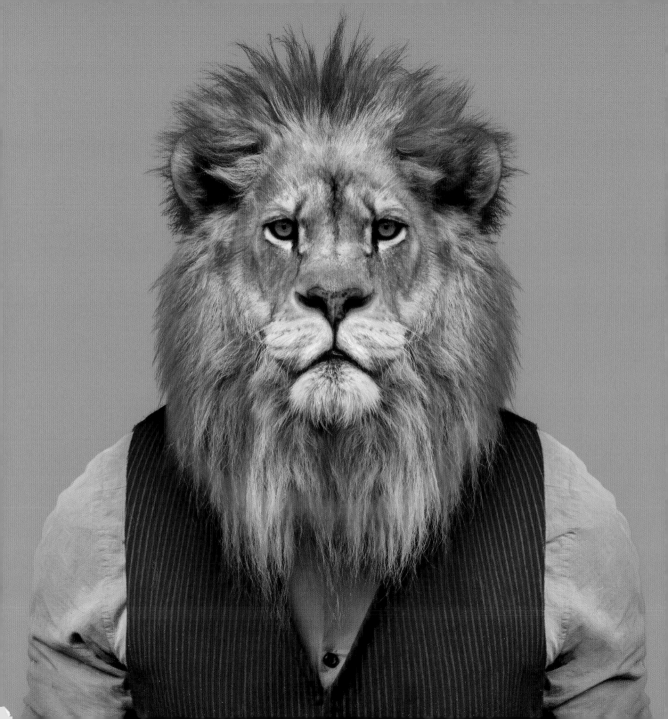

MOSES THE LION

DID YOU KNOW...

Two misconceptions about lions: They are not the largest of the big cats, but rather the second-largest, after tigers. And the lion has never been "King of the Jungle," since it never lives in jungle regions. However, lions are the only big-cat species in which the males have long manes. They can also roar louder than all other types of big cat. In fact, a lion's roar can be heard up to 5 miles (8 km) away. Lions' night vision is six times better than that of humans. In contrast to all other big cats, lions live in prides that include both genders and that are made up of two or three independent males and multiple females with their offspring. Lions also hunt as prides, although it is mainly the females who take care of that task. Previously, lions inhabited parts of Europe, all of Africa, the Middle East, North America, and northern India. Currently, however, they can be found only in a few regions of Africa, and in one isolated pride in India. If conservation measures are not implemented immediately, some experts estimate that lions will be practically extinct by 2050.

COMMON NAME
Lion

SCIENTIFIC NAME
Panthera leo

CONSERVATION STATUS
Vulnerable (VU)

POPULATION
23,000–39,000 individuals

HABITAT
Savanna and dry forested areas

SIZE / WEIGHT
⇨ ♀ 4.6–5.8 ft. (1.4–1.75 m)
⇨ ♂ 5.6–8.2 ft. (1.7–2.5 m)
⚖ ♀ 265–401 lb. (120–182 kg)
⚖ ♂ 331–551 lb. (150–250 kg)

GESTATION PERIOD
110 days

DIET
Gnus, impalas, zebras, buffalos, warthogs, nilgais, wild boar

LIFE SPAN
10–14 years

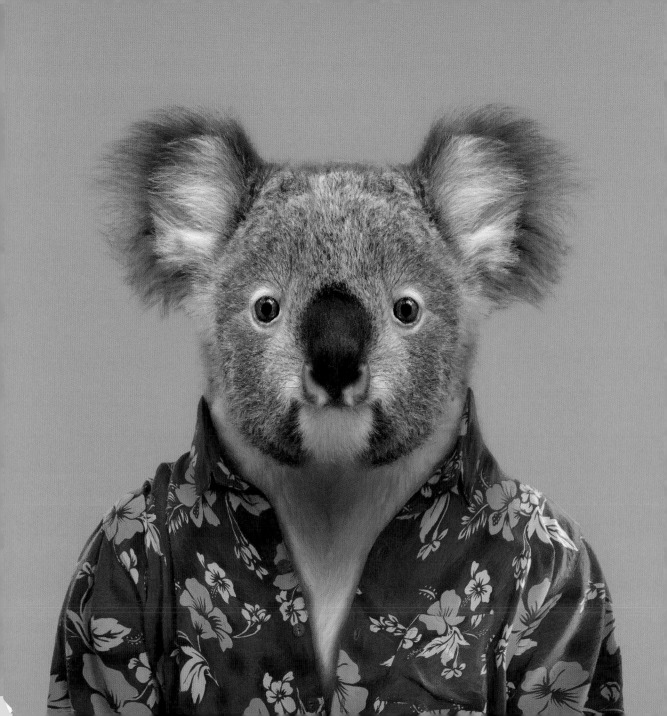

COOPER THE KOALA

DID YOU KNOW...

Koalas' front paws each have two thumbs, with claws that are used for climbing. Their hind paws each have one thumb and a first and second finger that are fused into a kind of hook that the koalas use to remove ticks. Male koalas mark "their" trees with sticky secretions from glands on their chests. Koalas have the greatest need for sleep of all mammals: up to 20 hours per day. During this time, they must digest their food, which mainly consists of eucalyptus leaves. Newborn koalas spend up to seven months in their mothers' pouches, drinking only their mothers' milk. In the next phase of their development, they are fed a substance that prepares their stomachs to digest poisonous eucalyptus leaves. Out of over 600 eucalyptus species, koalas eat the leaves of only around 12, which only adds to the endangerment of their species from deforestation. Although koalas look plump and rarely spend time on the ground, they run surprisingly quickly—without breaking a sweat, by the way, since they have no sweat glands.

COMMON NAME
Koala

SCIENTIFIC NAME
Phascolarctos cinereus

CONSERVATION STATUS
Vulnerable (VU)

POPULATION
100,000 bis 500,000 individuals in Australia

HABITAT
Eucalyptus forests

SIZE / WEIGHT
⇧ 23.6–33.5 in. (60–85 cm)
⚖ ♀ 8.8–24 lb. (4–11 kg)
⚖ ♂ 26–33 lb. (12–15 kg)

GESTATION PERIOD
35 days + 180 days in the bag

DIET
Eucalyptus leaves

LIFE SPAN
10–15 years

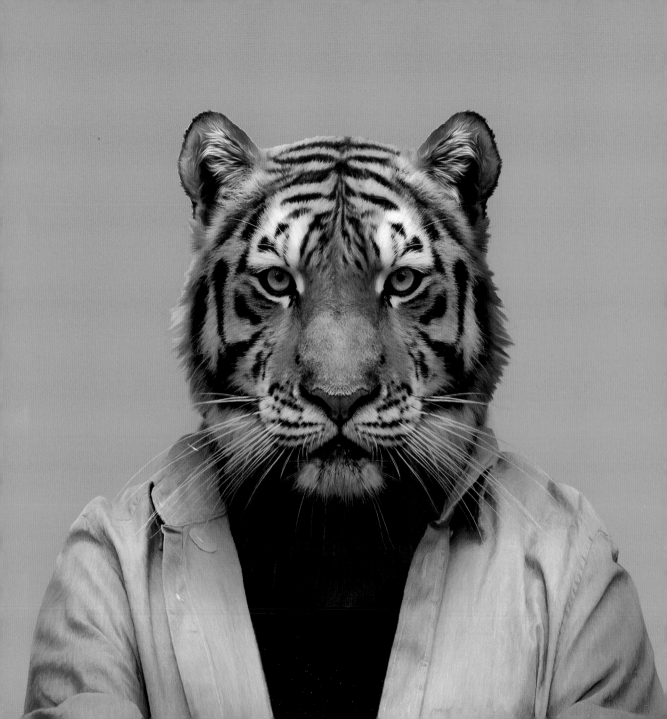

MISHKA THE BENGAL TIGER

DID YOU KNOW...

The Bengal tiger is currently the largest cat species in existence and the national animal of India and Bangladesh. The striped pattern on each tiger's coat is as unique as a fingerprint. Tigers can jump about 16.5 ft. (5 m) vertically and 33 ft. (10 m) horizontally. The tiger's roar, which can be heard from 1.9 miles (3 km) away, emits infrasonic waves that paralyze its prey, and a blow from one of a tiger's gigantic paws can kill an adult human. Whereas tigers have a very good sense of hearing and keen night vision, they can identify their prey only by its movements. In the wild, tigers stalk their prey for up to 8 days. Male tigers keep to themselves, but control specific territories where multiple females live with their cubs. Three types of tiger, the Bali tiger, the Javan tiger, and the Caspian tiger, have already died out, and the South China tiger is close to being eradicated. They have been hunted extensively for their organs, parts of which are used in the production of certain natural remedies. Bengal tigers are also classed as threatened.

COMMON NAME
Bengal tiger

SCIENTIFIC NAME
Panthera tigris tigris

CONSERVATION STATUS
Endangered (EN)

POPULATION
2,226 individuals in 2014

HABITAT
Variety of habitats: grasslands, tropical / subtropical rainforests

SIZE / WEIGHT
⇨ ♀ 7.9–8.7 ft. (2.4–2.65 m)
⇨ ♂ 8.9–10.2 ft. (2.7–3.1 m)
🕳 ♀ 308 lb. (140 kg)
🕳 ♂ 485 lb. (220 kg)

GESTATION PERIOD
98–108 days

DIET
Antelope, deer, wild boar, monkeys, rabbits, waterfowl

LIFE SPAN
12–14 years

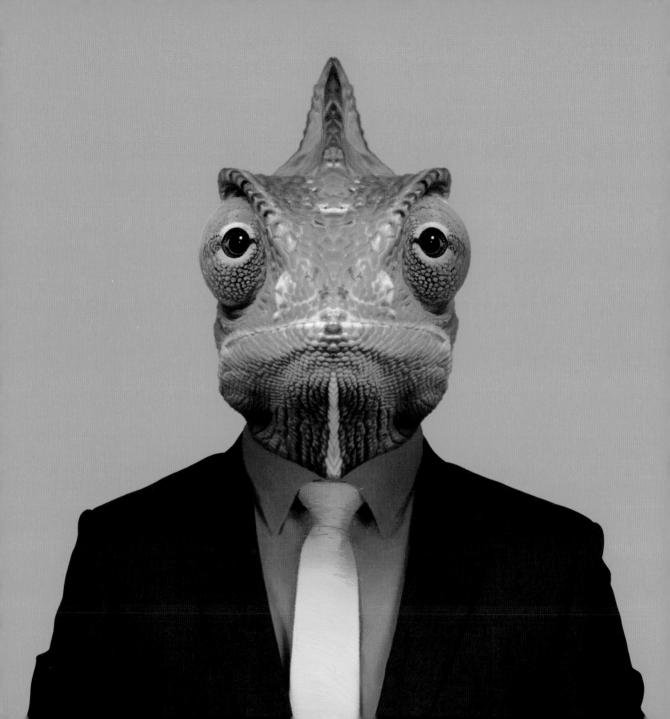

YASSER THE VEILED CHAMELEON

COMMON NAME
Veiled chameleon

SCIENTIFIC NAME
Chamaeleo calyptratus

CONSERVATION STATUS
Least Concern (LC)

POPULATION
Common

HABITAT
In trees in forested mountain areas
of the Arabian Peninsula

SIZE / WEIGHT
⇨ ♀ 13.7 in. (35 cm)
⇨ ♂ 17–24 in. (43–61 cm)
🏋 ♀ 3–4 oz. (85–118 g)
🏋 ♂ 3–6 oz. (85–170 g)

BROODING PERIOD
150–200 days

DIET
Insects, some vegetables, small mice

LIFE SPAN
Up to 5 years

DID YOU KNOW...

Chameleons can rapidly change color depending on their mood. If these ex-
tremely solitary creatures are approached, even by another chameleon (out-
side the mating season), they immediately become stressed and change color.
Chameleons' tongues are twice as long as their bodies and are covered in
sticky saliva that is around 400 times more viscous than that of humans. They
use their tongues to catch their food, which comprises mainly small insects.
Veiled chameleons are the only subspecies that also eats plants, from which
they also derive their water intake. Otherwise, chameleons' only sources of
water are drops of dew and condensation. These collect on their large head
casques and can then be funneled into their mouths. Chameleons' eyes are
unique in the animal world—they can move independently of one another to
cover a 360-degree field of vision. Like cameras, they can also quickly zoom
in on individual objects.

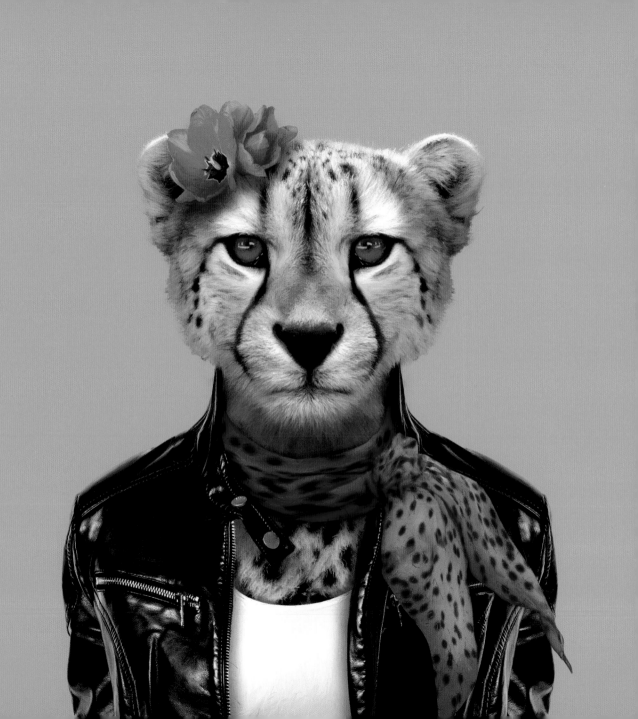

NAYNA THE CHEETAH

DID YOU KNOW...

With a top speed of up to 71 mph (115 km/h) over short distances of one-quarter to one-third of a mile (400–500 m), cheetahs are the fastest land animals in the world. They hunt during the day, when their stronger competitors for prey (hyenas, lions, large baboons, and leopards) are asleep, and the black markings around the cheetahs' eyes absorb the glare of the sun. While males live in small groups, often consisting of their own brothers, the females are solitary and raise their cubs on their own. Cheetah females can have up to five cubs in one litter. However, many juveniles are killed by other predators, often in their first year of life. Cheetahs' tails are over 3.3 ft. (1 m) long, flat, and muscular, and are used for stability, balance, and to help the animals change direction while running. Cheetahs are supposed 'not to roar'; instead, they use bird-like cawing noises to identify themselves or to summon their cubs. Cheetahs are one of the most endangered species: Worldwide, there are currently only about 6,700 living in the wild.

COMMON NAME
Cheetah

SCIENTIFIC NAME
Acinonyx jubatus

CONSERVATION STATUS
Vulnerable (VU)

POPULATION
6,700 individuals

HABITAT
Open and partially closed savannas

SIZE / WEIGHT
⇧ 2.5–3 ft. (0.8–0.9 m)
⇨ 4.9 ft. (1.5 m)
⬛ 110–140 lb. (50–64 kg)

GESTATION PERIOD
90–98 days

DIET
Prey animals, mainly antelope

LIFE SPAN
10–12 years

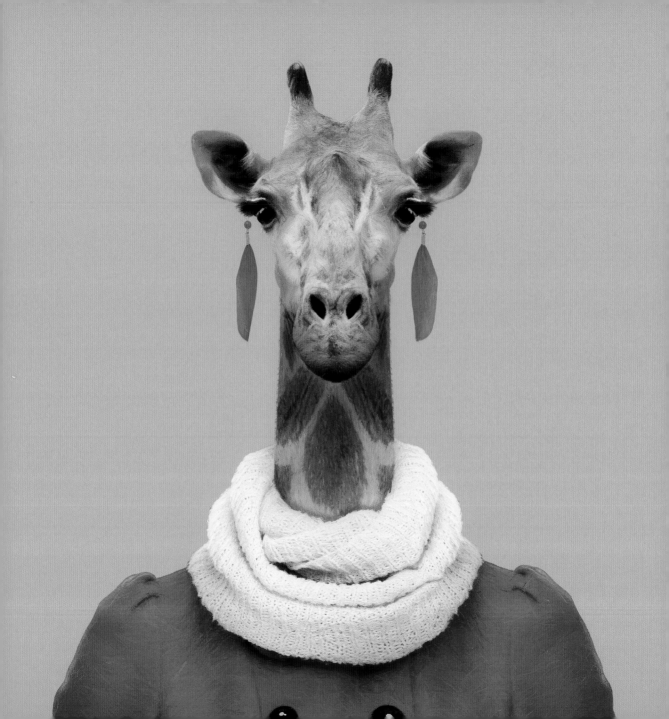

AYANA THE NORTHERN GIRAFFE

COMMON NAME
Northern giraffe

SCIENTIFIC NAME
Giraffa camelopardalis

CONSERVATION STATUS
Vulnerable (VU)

POPULATION
4,500 individuals

HABITAT
Savanna, grassland, and open woodland

SIZE / WEIGHT
⇡ 14.1–18.7 ft. (4.3–5.7 m)
⚖ ♀ 1,825 lb. (828 kg)
⚖ ♂ 2,628 lb. (1,192 kg)

GESTATION PERIOD
400–460 days

DIET
Acacia leaves that other animals cannot reach

LIFE SPAN
Up to 25 years

DID YOU KNOW...

These long-necked animals grow to up to 19 ft. (5.8 m) in height, making them the world's tallest land animals. Their long necks, however, make drinking difficult: They have to splay their legs and bend forward—a maneuver that makes them temporarily vulnerable to crocodile attacks. Their other natural predators include leopards, hyenas, and wild dogs. Although giraffes can run at speeds of up to 34 mph (55 km/h), they don't always run away immediately when attacked. Instead, they stand and fight, primarily using their large hooves, which can inflict considerable damage. Giraffes' tongues—which can be an impressive 19.7 in. (50 cm) long—have several different functions: Giraffes use them to pull leaves from trees for food, as well as to clean their own ears and noses. Baby giraffes must be able to outrun danger at an early age. They can, therefore, stand on their own just 30 minutes after being born (a process which involves them falling approximately 5 ft. (1.5 m) from their mother's standing body), and run just ten hours later. Giraffes need just two hours' sleep each day. Incidentally, they are the only vertebrates that have never been seen to yawn.

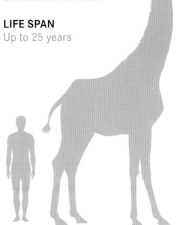

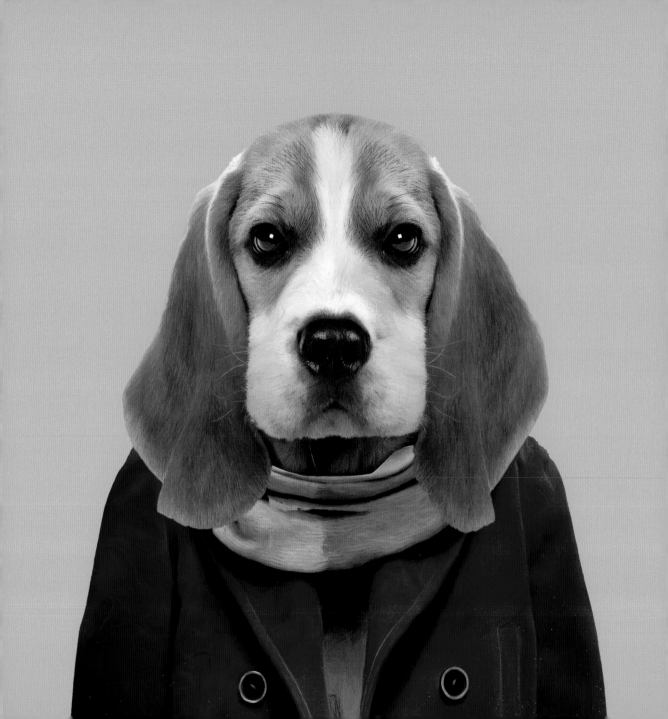

AARON THE BEAGLE

COMMON NAME
Beagle

SCIENTIFIC NAME
Canis lupus familiaris

CONSERVATION STATUS
Not Evaluated (NE)

POPULATION
Very common

HABITAT
Domestic animal (pet)

SIZE / WEIGHT
⇡ 13–16 in. (33–41 cm)
♀ 20–23 lb. (9.1–10.4 kg)
♂ 22–25 lb. (10.0–11.3 kg)

GESTATION PERIOD
58–62 days

DIET
Biologically carnivorous,
but omnivorous as pets

LIFE SPAN
12–16 years

DID YOU KNOW...

This breed of dog measures between 13 and 16 in. (33 to 41 cm) at the shoulder and originates from England, where it was bred specifically for hare and rabbit hunting. Although the breed has existed for 2000 years, the beagles of today are the result of crossing the Northern Hound with the Southern Hound to strengthen hunting traits, such as speed and courage. Beagles are ravenous, so their owners must keep their diet in check so that they don't become overweight. They have an excellent sense of smell, which is why they are often trained as sniffer dogs to detect drugs or explosives. Unfortunately, they are also often used for animal testing since they are calm and easy to raise, and are not plagued by hereditary diseases. Beagles are a friendly dog breed and, since they hunt in packs, they also get along well with other dogs. The most famous beagle is, incidentally, Snoopy, of Peanuts fame.

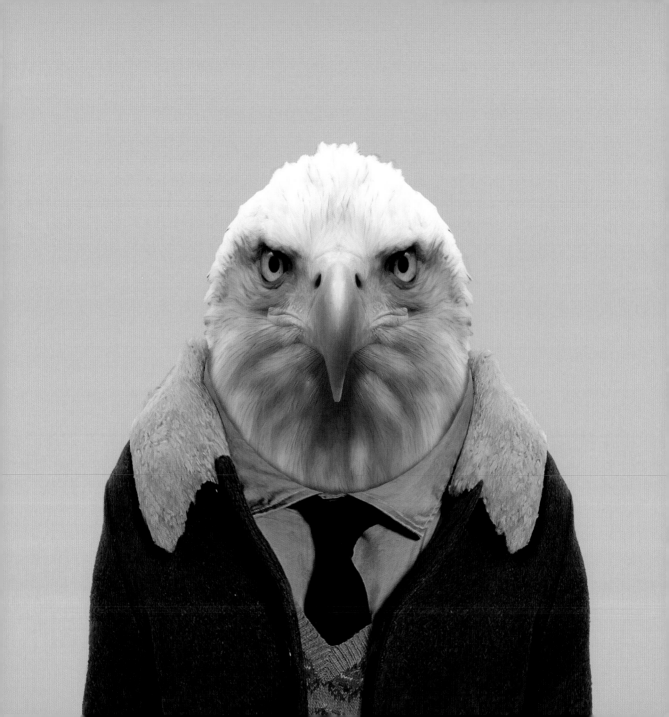

JOHN THE BALD EAGLE

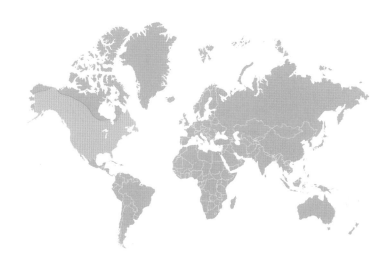

DID YOU KNOW...

Young bald eagles have gray heads until they develop their typical white head feathering, at around four to five years old. These large birds of prey are monogamous and mate for life, and female eagles are considerably larger than males. The females lay an average of two eggs in a gigantic nest, which is also known as an aerie. The largest aerie ever found was 9.8 ft. (3 m) wide and 19.7 ft. (6 m) tall and weighed 1.97 tons (2 tonnes). Eagles' eyesight is extraordinarily keen: They can identify prey from great distances and even perceive UV light. They also have semitransparent third eyelids that protect and moisten their eyes—meaning that they never have to take their eyes off their prey, not even for a fraction of a second. Although they are not good swimmers, they do swim to drag their prey (fish too heavy to lift out of the water) onto land. The bald eagle population was most notably threatened by the use of the pesticide DDT, but has recovered since DDT was banned in 1972.

COMMON NAME
Bald eagle or American eagle

SCIENTIFIC NAME
Haliaeetus leucocephalus

CONSERVATION STATUS
Least Concern (LC)

POPULATION
70,000 individuals

HABITAT
Areas near bodies of water

SIZE / WEIGHT
⇧ ♀ 2.9–3.1 ft. (0.89–96 m)
⇧ ♂ 2.3–2.8 ft. (0.7–0.86 m)
⇨ span 5.9–7.5 ft. (1.8–2.3 m)
⬛ 6.6–13.9 lb. (3–6.3 kg)

BROODING PERIOD
35 days

DIET
Fish, carrion, small birds, and small rodents

LIFE SPAN
20–30 years

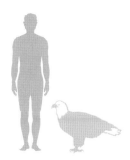

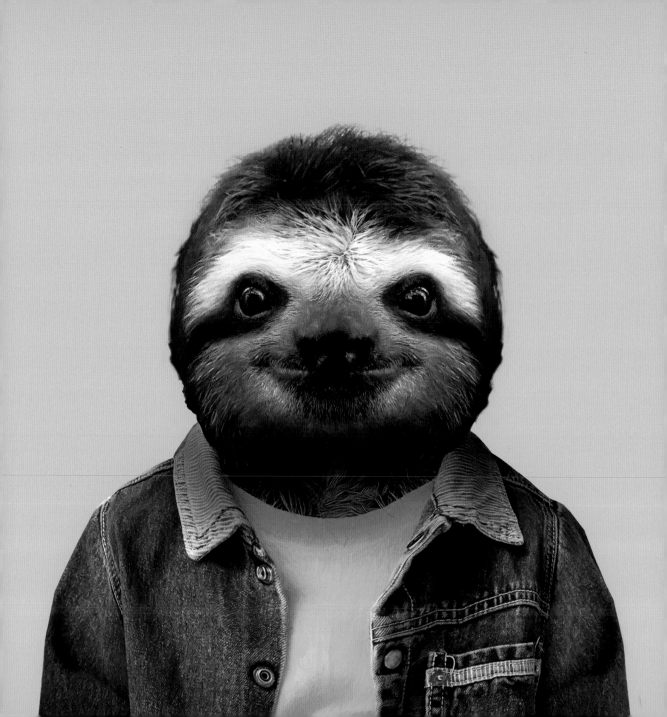

JOÃO THE BROWN-THROATED SLOTH

DID YOU KNOW...

Brown-throated sloths are the most common type of sloth. They have three toes, while all other sloth species have only two. Each of the three toes ends in a large claw. Sloths use these claws to hold onto the branches of the trees in which they spend their entire lives, leaving them only every few days to urinate and defecate. Sloths get their name from the fact that they move extremely slowly and sleep about 10 hours per day. This is because their diet consists exclusively of leaves, which provide minimal energy and which they digest over a period of days. They are fantastic swimmers, however, and can easily cross a river if there is an opportunity to find a potential partner on the other side. Their defense strategy against their enemies (such as jaguars, eagles, and snakes) consists of using their slightly greenish fur to blend in with the branches of trees. Like owls, sloths can turn their heads 300 degrees, so they always have an eye on their surroundings.

COMMON NAME
Brown-throated sloth

SCIENTIFIC NAME
Bradypus variegatus

CONSERVATION STATUS
Least Concern (LC)

POPULATION
Unknown

HABITAT
Evergreen areas, dry forests, and tropical rainforests

SIZE / WEIGHT
⇨ 17–31 in. (42–80 cm)
⚖ 5–13.9 lb. (2.25–6.3 kg)

GESTATION PERIOD
120–180 days

DIET
Leaves from a wide variety of trees

LIFE SPAN
30–40 years

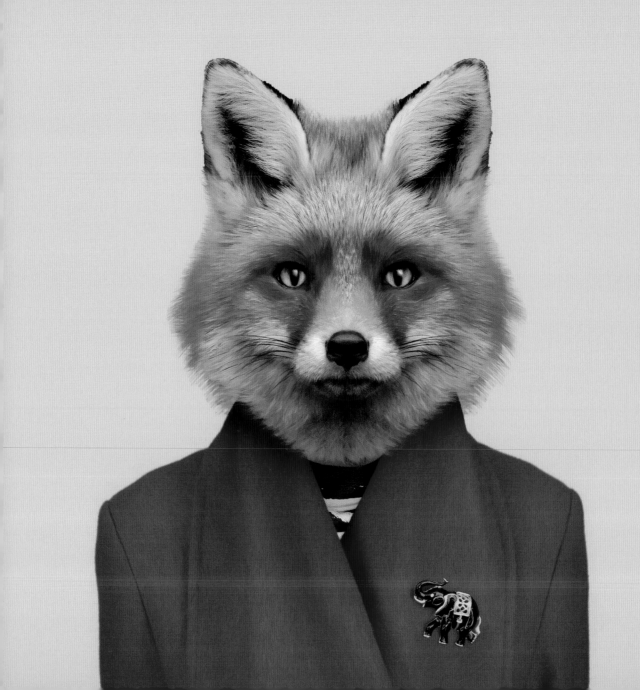

EVIE THE RED FOX

DID YOU KNOW...

Red foxes are the world's most widely distributed predators. Although biologically they belong to the dog family, they have many similarities to cats: They have vertical pupils, can climb trees, and play with their prey before consuming it. Foxes hunt predominantly at night. They have a reflective coating on their eyes, sensitive whiskers, and an excellent sense of hearing, all of which help them hunt in the dark. Their excellent hearing also allows them to sense low frequencies, which help them detect rodents—even underground. They also hunt even when they are not hungry and hide (cache) any extra food for later consumption. Foxes were introduced in Australia partially in an attempt to contain the overflowing population of rabbits, but the foxes themselves nearly reached plague levels. By contrast, in Europe, where foxes have been hunted for centuries, they had to be protected from extinction by new laws. In Japan, foxes are considered sacred—people believe they possess magical powers.

COMMON NAME
Red fox

SCIENTIFIC NAME
Vulpes vulpes

CONSERVATION STATUS
Least Concern (LC)

POPULATION
Very common

HABITAT
Forests (except rainforests), grasslands, coasts, tundra, mountain plateaus

SIZE / WEIGHT
⇡ 13.7–19.9 in. (35–50 cm)
⚖ 8–31 lb. (3.6–14 kg)

GESTATION PERIOD
52–53 days

DIET
Invertebrates such as insects, worms, crabs, mollusks, plus small rodents

LIFE SPAN
Up to 5 years

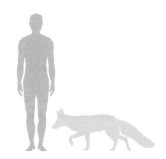

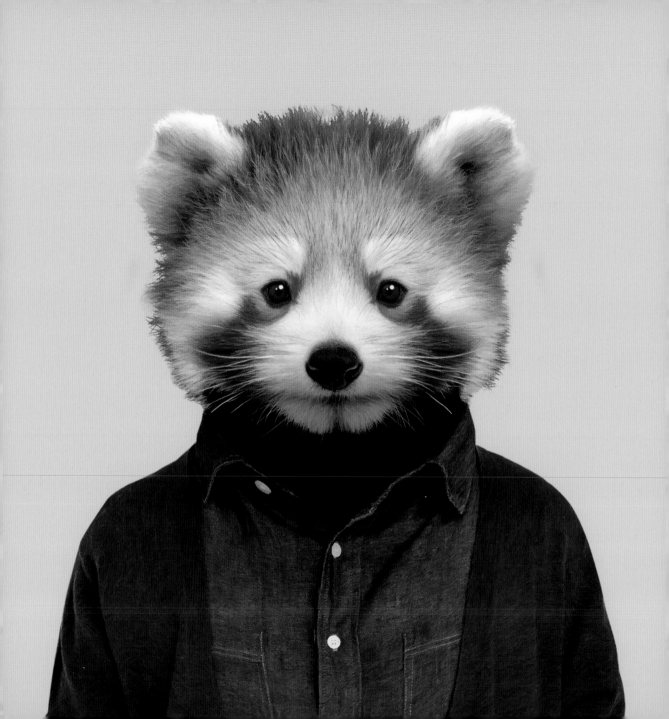

CHANG THE RED PANDA

DID YOU KNOW...

Red pandas are in the Ailuridae, or cat-bear, family, and are not related to the giant panda. The red panda, whose name probably stems from the Nepalese pónya, which means "paw" or "eater of bamboo," was named before the giant panda. Although red pandas are officially carnivores, they feed mainly on bamboo and fruit. They have thick, bushy tails that they wrap around themselves like blankets when the temperature drops. Their front paws have a "false thumb," which is an extension of their wrist, along with fingers that they use to grasp their food. Additionally, like cats, they can partially extend their claws for a better grip when climbing trees—and they climb down again headfirst. Red pandas communicate using a wide range of noises, from bird-like chirps to deep, bear-like growls. Red pandas are endangered due to their limited habitat and their resultant inbreeding. Despite political efforts to protect them, the number of red pandas living in the wild is steadily decreasing.

COMMON NAME
Red panda

SCIENTIFIC NAME
Ailurus fulgens

CONSERVATION STATUS
Endangered (EN)

POPULATION
Fewer than 10,000 individuals
still living in the wild

HABITAT
Bamboo and coniferous forests,
and old trees in mountainous regions

SIZE / WEIGHT
⚲ 20–25 in. (50–64 cm)
⚖ 6.6–13.6 lb. (3–6.2 kg)

GESTATION PERIOD
112–158 days

DIET
Bamboo, supplemented with berries,
fruits, fungi, roots, and smaller animals

LIFE SPAN
12–14 years

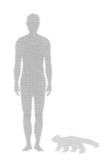

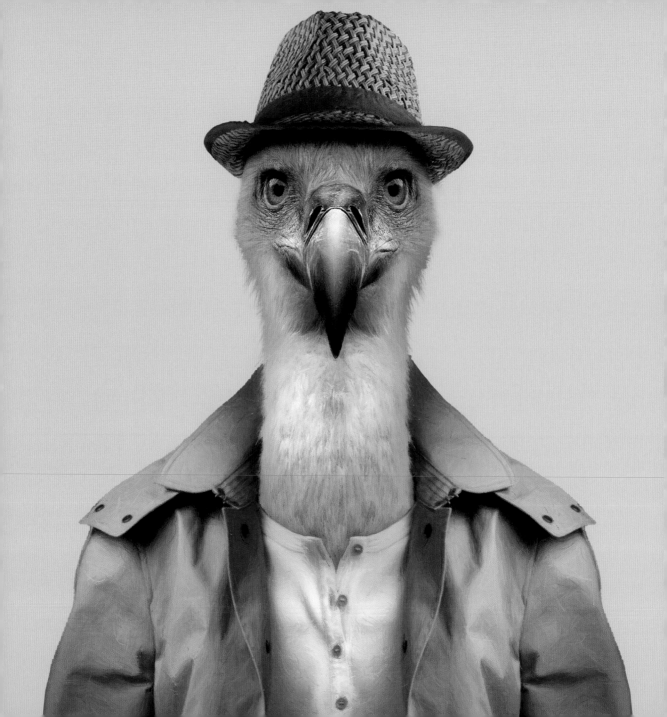

BREV THE GRIFFON VULTURE

DID YOU KNOW...

Griffon vultures can eat up to 20 percent of their own weight during a single meal, which normally consists of carrion. They seldom attack sick or dying animals. Their bodies produce specific digestive acids that destroy botulism, anthrax, and cholera bacteria, enabling the vultures to feed on infected carcasses with no ill effects. Vultures are important for the ecosystem, as they quickly consume carrion that would otherwise putrefy and cause disease. Griffon vultures urinate directly on their own feet in order to disinfect them. These huge birds can fly tremendous distances in search of food: One study was able to follow a vulture's journey from its nest in northern Tanzania all the way to Ethiopia via Kenya and the Sudan. The largest member of the family, the Rüppell's griffon vulture, is also the world's largest flying bird. It can fly at heights of over 6.2 miles (10 km)—a record that was proven when a Rüppell's griffon vulture collided with an airplane. The proliferation of air traffic has become a great threat to their populations.

COMMON NAME
Griffon vulture

SCIENTIFIC NAME
Gyps fulvus

CONSERVATION STATUS
Least Concern (LC)

POPULATION
500,000–1 million individuals

HABITAT
Valleys of mountainous areas

SIZE / WEIGHT
⇧ 37–48 in. (93–122 cm)
⇨ span 7.5–9.2 ft. (2.3–2.8 m)
⚖ 14–25 lb. (6.2–11.3 kg)

BROODING PERIOD
48–59 days

DIET
Carrion

LIFE SPAN
Up to 25 years

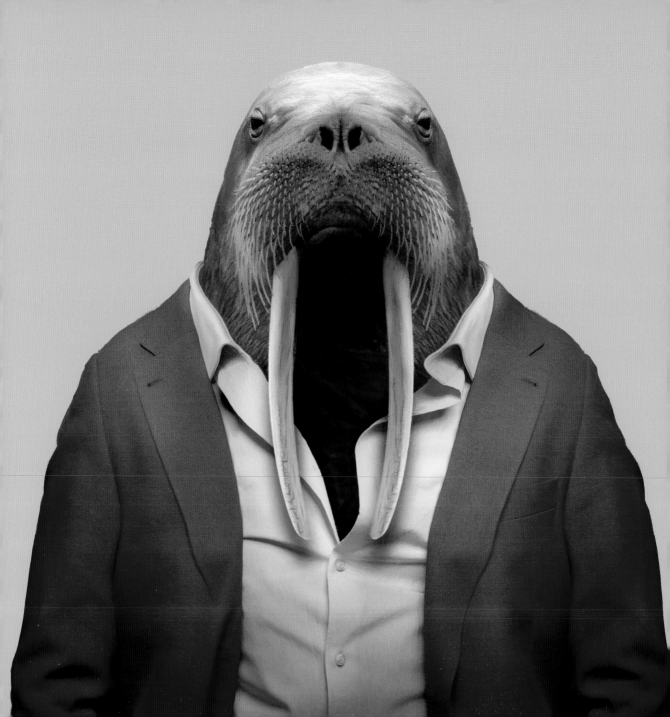

JOSEPH THE WALRUS

DID YOU KNOW...

Walruses have an extremely thick layer of fat, or blubber, which allows them to survive in the extreme cold. Their impressive ivory tusks are practical: Walruses use them to break the ice, to defend themselves (in general and when males fight one another during the mating season), and to dig for invertebrates, especially mollusks, on the ocean floor. One underwater dive of between 5 and 20 minutes, to a depth of 230 ft. (70 m), can result in a meal of 60 mollusks. To find food despite their poor vision, walruses use their many, highly sensitive whiskers, or vibrissae, to feel for invertebrates. Adult walruses require about 55 lb. (25 kg) of food per day. Walruses live very peacefully in gender-specific groups until the mating season, when males engage in fierce fights for the right to impregnate an entire group of females. Walruses have long been hunted for their ivory tusks, often in mass slaughters. Currently, conservation laws are ensuring that their population rebounds.

COMMON NAME
Walrus

SCIENTIFIC NAME
Odobenus rosmarus

CONSERVATION STATUS
Vulnerable (VU)

POPULATION
112,500 individuals

HABITAT
Arctic Ocean

SIZE / WEIGHT
⇨ 7.2–11.8 ft. (2.2–3.6 m)
⚖ 1,300–4,400 lb. (600–2,000 kg)

GESTATION PERIOD
331 days + 90–150 days
(delayed implantation)

DIET
Small invertebrates, especially mollusks

LIFE SPAN
30–40 years

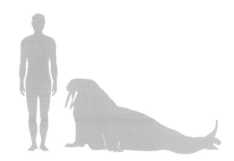

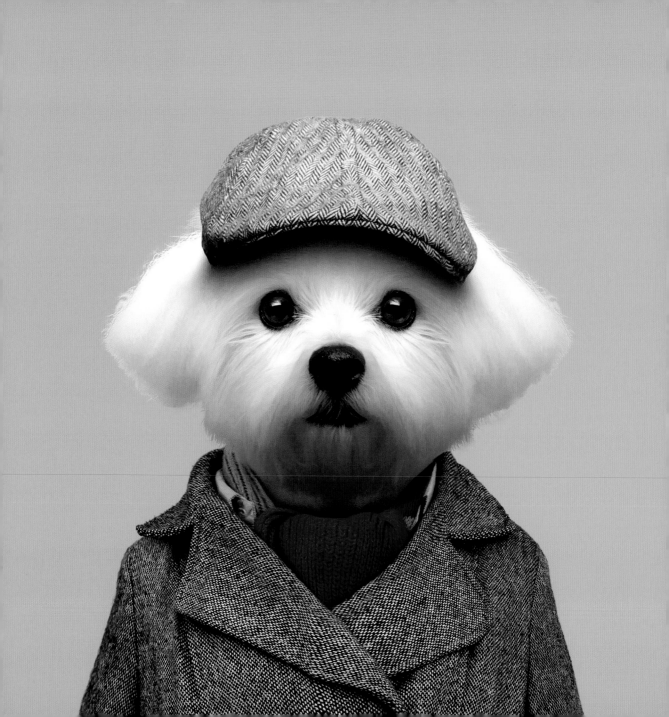

ZAZU THE MALTESE

COMMON NAME
Maltese

SCIENTIFIC NAME
Canis familiaris maelitacus

CONSERVATION STATUS
Not Evaluated (NE)

POPULATION
Common

HABITAT
Domestic animal (pet)

SIZE / WEIGHT
⇧ 8–10 in. (20–25 cm)
♀ 3–8 lb. (1.4–3.6 kg)
♂ 2–7 lb. (0.91–3.2 kg)

GESTATION PERIOD
59–65 days

DIET
Biologically carnivorous, but omnivorous as pets

LIFE SPAN
12–15 years

DID YOU KNOW...

Although Maltese dogs probably do originate from the Mediterranean region, they are not named after the island of Malta. Instead, their name comes from the Semitic word màlat, which means "refuge" or "harbor". For many years, these little dogs were used to hunt rats on boats and in harbors, and it was only during the Middle Ages that they became fashionable among the upper classes. One of the reasons for this increase in popularity was the belief that their body heat—which, like that of all dogs, is slightly above human body temperature—had pain-relieving powers. The Maltese is a member of the toy group of dog breeds; the smaller "teacup" Maltese is not an officially recognized breed. Incidentally, all dogs are capable of learning and remembering approximately 250 to 500 words. Various studies have also shown that some dogs can detect diseases in humans—such as cancer, diabetes and epilepsy—by scent, even before the first symptoms emerge.

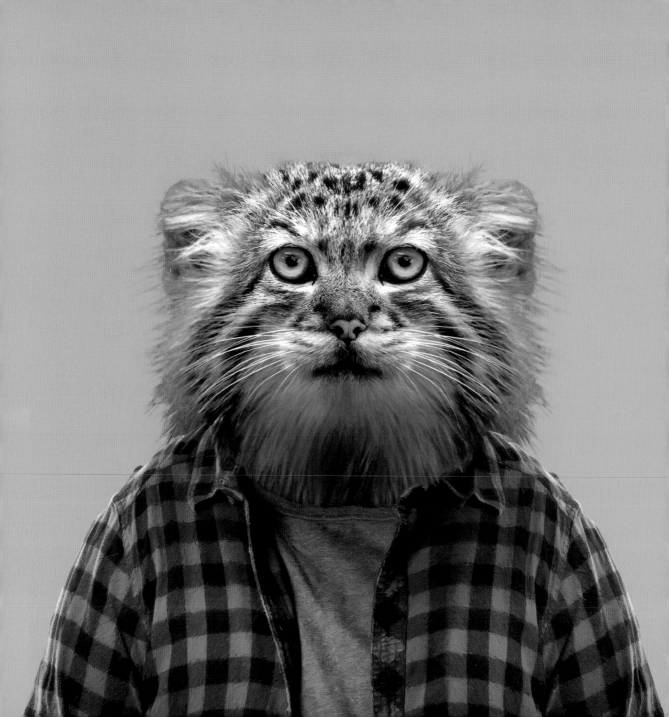

KHULAN THE PALLAS'S CAT

DID YOU KNOW...

To protect them from the extreme cold in their habitat, Pallas's cats have the longest and thickest fur of all cats. The color of their fur changes depending on the season: In winter, it's gray like the barren stones of their hunting grounds; in summer, ochre stripes appear in their fur to blend in with the steppe between the stones. Pallas's cats are between 18 and 26 in. (45–65 cm) long, with tails that are 8 to 12 in. (21–31 cm) long, and they can growl like small dogs. Though they may look cute and fluffy, they are extremely aggressive, solitary animals. Even their mating season only lasts one or two days. Young cats are ready to hunt and survive on their own at 6 months of age. Unlike other cats, the pupils of Pallas's cats contract into small circles rather than vertical slits. Since they cannot run fast, Pallas's cats rely on the element of surprise when they hunt, hiding and then pouncing on their prey in one bound. Their ears are on the sides of their head, which helps them stay hidden among the rocks. Their ears have resulted in a not-so-nice scientific name: manul comes from the Greek for "ugly ears."

COMMON NAME
Pallas's cat

SCIENTIFIC NAME
Otocolobus manul

CONSERVATION STATUS
Nearly Threatened (NT)

POPULATION
15,000 individuals

HABITAT
Areas with few trees, such as barren mountains, steppes, and semideserts

SIZE / WEIGHT
⇨ 18–26 in. (45–65 cm)
🏋 5.5–9.9 lb. (2.5–4.5 kg)

GESTATION PERIOD
60–75 days

DIET
Birds and small rodents, especially pikas

LIFE SPAN
Up to 39 months in the wild

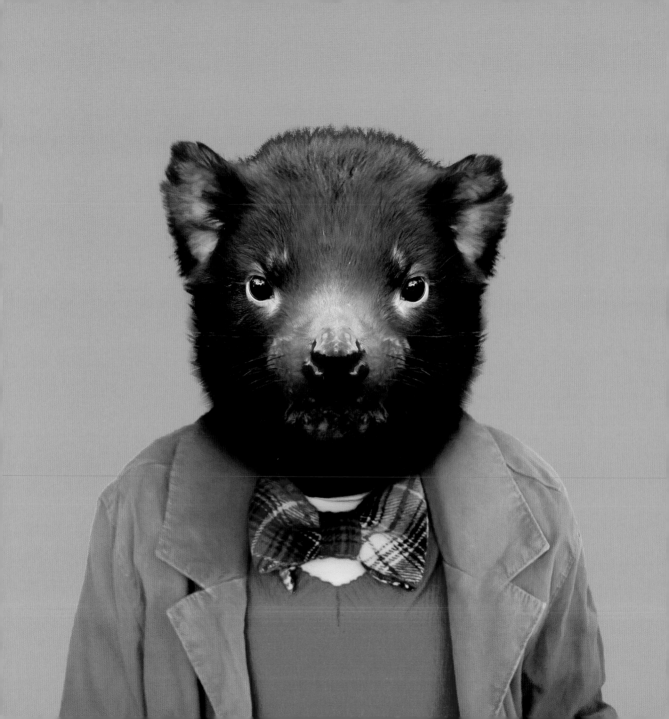

HUNTER THE TASMANIAN DEVIL

COMMON NAME
Tasmanian devil

SCIENTIFIC NAME
Sarcophilus harrisii

CONSERVATION STATUS
Endangered (EN)

POPULATION
10,000–25,000 individuals

HABITAT
Tasmania, including the outskirts
of urban areas

SIZE / WEIGHT
⇨ 20–31 in. (51–79 cm)
▲ 9–26.5 lb. (4–12 kg)

GESTATION PERIOD
21 days

DIET
Carrion and prey up to the
size of a small kangaroo

LIFE SPAN
5–8 years

DID YOU KNOW...

Tasmanian devils are once more under threat. Not from humans, as they were until 1941, but from a malignant facial tumor that has been attacking the species for approximately the past 20 years and for which there is, as yet, no known cure. Still, Tasmanian devils, the world's largest carnivorous dasyurids, defend themselves bravely against their natural enemies, such as dingoes. They do this by exuding an unpleasant, musk-like odor, screaming deafeningly loudly, and biting ferociously—even amongst themselves. Even as embryos in their mother's pouches, Tasmanian devils must fight to survive. The females give birth to up to 30 embryos, each the size of a grain of rice, which then attempt to attach themselves to one of just four teats inside the pouch. Only the strongest survive. Tasmanian devils are also equipped to survive short periods of food scarcity by storing fat in their tails. Tasmanian devils tend to live alone. They can open their jaws at an angle of up to 80 degrees and have one of the strongest bites in the animal kingdom. They can easily grind up the bones of their prey, which may include animals as big as kangaroos and which is usually in the form of carrion.

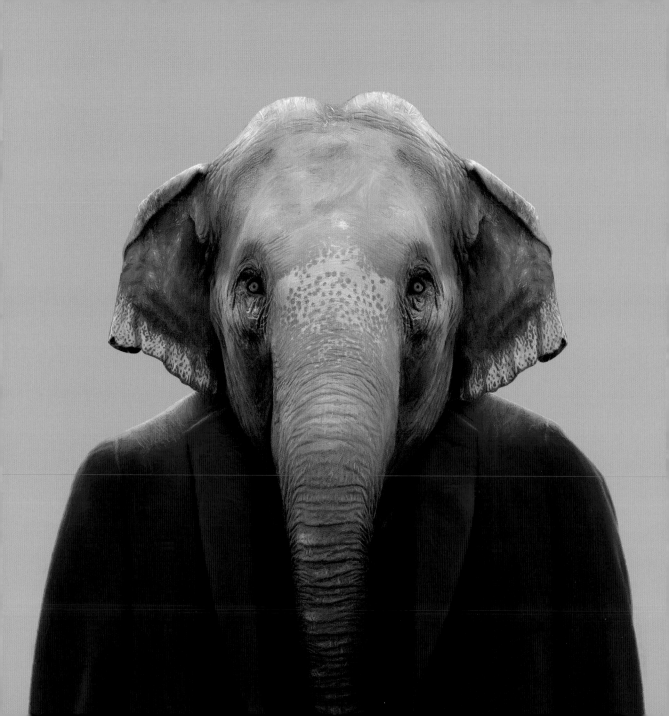

BAGUS THE ASIAN ELEPHANT

DID YOU KNOW...

There are several physical differences between Asian and African elephants, most noticeably in their body and ear size. Asian elephants are smaller, with proportionately much daintier, more rounded ears. Due to their size (they are the biggest land mammals in the world), their weight of up to 4.4 US tons (4 metric tons), and the structure of their leg muscles, elephants are among the few mammals that cannot jump. They are, however, good swimmers, using their trunks as snorkels. They also use their trunks to cover themselves in dirt and mud to protect their sensitive skin from sunburn. In addition, they use them to gather food (up to 300 lb. (136 kg) per day) and to suck up water (they can drink 70 gal. (300 l) per day). And of course, they smell with their trunks, too. Incidentally, an elephant's sense of smell is one of the keenest in the animal kingdom. Elephants have giant brains weighing up to 11 lb. (5 kg). They are very intelligent and empathetic creatures who can also suffer from stress and depression. They are also among those species who perform specific mourning rituals and who feel and express grief at the death of one of their kind.

COMMON NAME
Asian or Asiatic elephant

SCIENTIFIC NAME
Elephas maximus

CONSERVATION STATUS
Endangered (EN)

POPULATION
25,000–33,000 individuals

HABITAT
Grasslands and several types of forest

SIZE / WEIGHT
⇑ 6.6–9.8 ft. (2–3 m)
🏋 2.3–5.5 tons (2–4.9 tonnes)

GESTATION PERIOD
615–668 days

DIET
Grass, roots, fruit, tree bark

LIFE SPAN
Up to 60 years

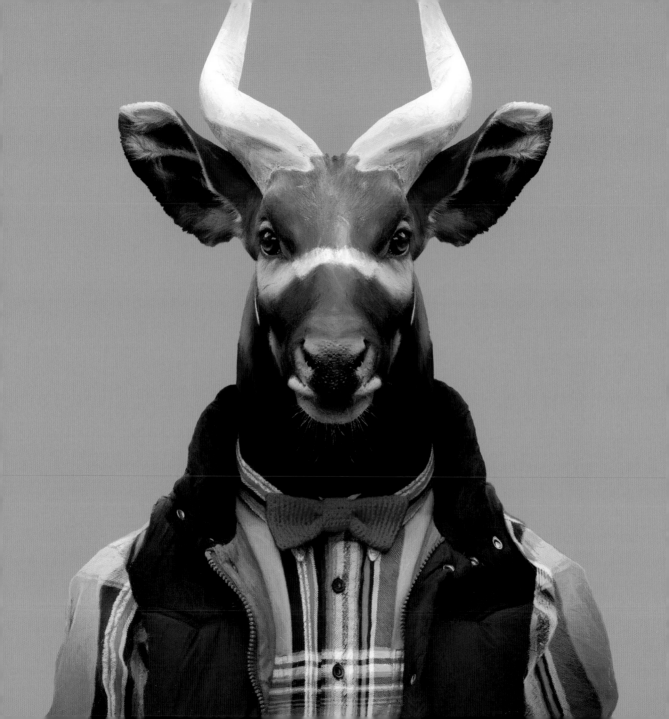

RÉGIS THE BONGO

DID YOU KNOW...

Bongos are Africa's largest antelope species. There are two subspecies, the western, or lowland, bongo and the eastern, or mountain, bongo. The mountain bongo is critically endangered, and there are less than 200 members of this subspecies still living in the wild. Bongos are characterized by their long horns. Unlike other antelope species, they do not use these as weapons; instead, they employ them primarily for pushing aside branches and twigs while on the run. They grasp their food, which comprises leaves and plants, with their long, muscular tongues, and use their large ears for the early detection of predators, which include leopards and sometimes lions. Male bongos are solitary animals, whereas the females live in groups of up to 50. Mothers conceal their babies in the thick rainforest vegetation, returning to their hiding places only to nurse them. At one week old, however, the babies are already capable of running with the herd.

COMMON NAME
Bongo

SCIENTIFIC NAME
Tragelaphus eurycerus

CONSERVATION STATUS
Nearly Threatened (NT)

POPULATION
15,000–25,000 individuals

HABITAT
Tropical rainforests

SIZE / WEIGHT
⇧ 3.6–4.3 ft. (1–1.3 m)
⇨ 7.1–10.3 ft. (2.15–3.15 m)
⚖ ♀ 331–518 lb. (150–235 kg)
⚖ ♂ 485–893 lb. (220–405 kg)

GESTATION PERIOD
282–285 days

DIET
Leaves, shoots, and grass

LIFE SPAN
Up to 19 years

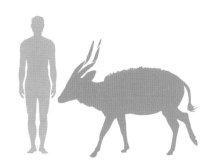

LIAM THE AMERICAN BLACK BEAR

DID YOU KNOW...

Despite their name, American black bears may be brown, tan, or even white. They are smaller than polar bears or brown bears and considerably more placid than grizzly bears. In skirmishes with attackers, they prefer to run rather than fight. They also climb trees, which they do surprisingly easily considering their physical bulk. American black bears are solitary animals that cover long distances each day in search of food. In doing so, the more slender members of the species can reach speeds of up to 30 mph (48 km/h). They are also very good swimmers. They have a highly developed sense of smell and sometimes stand on their hind legs, scenting the wind. The females produce cubs approximately every two years. Each litter contains between two and six cubs, which stay with their mother for around 18 months. Black bears hibernate less deeply than other animals, and can wake immediately if they sense danger. There are 16 types of black bears, one of which is the Kermode, or spirit bear, which lives only in British Columbia. Ten percent of spirit bears have completely white fur.

COMMON NAME
American black bear

SCIENTIFIC NAME
Ursus americanus

CONSERVATION STATUS
Least Concern (LC)

POPULATION
850,000–950,000 individuals

HABITAT
Forests, areas of shrubs, swamps, tundra, high mountain areas

SIZE / WEIGHT
⇧ 28–41 in. (70–105 cm)
⇨ 47–79 in. (120–200 cm)
🏋 ♀ 90–375 lb. (41–170 kg)
🏋 ♂ 126–551 lb. (57–250 kg)

GESTATION PERIOD
220–235 days (delayed implantation)
Pregnancy 60–70 days

DIET
Grass, fruit, nuts, carrion, insects, salmon, crabs, honey, small animals

LIFE SPAN 21–33 years

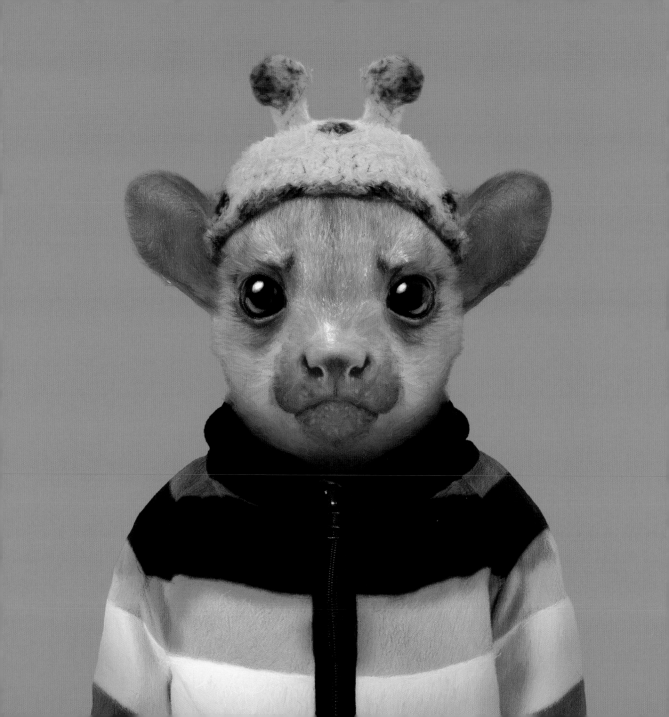

RIKY THE KINKAJOU

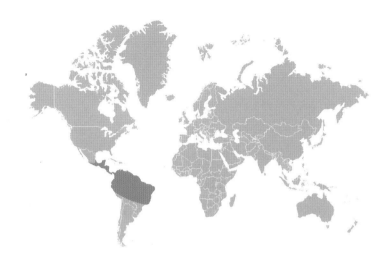

COMMON NAME
Kinkajou

SCIENTIFIC NAME
Potos flavus

CONSERVATION STATUS
Least Concern (LC)

POPULATION
Common

HABITAT
Trees in tropical rainforests

SIZE / WEIGHT
⇨ 16–24 in. (40–60 cm)
⬛ 3–10 lb. (1.4–4.6 kg)

GESTATION PERIOD
98–120 days

DIET
Honey, fruit, and small mammals

LIFE SPAN
Up to 23 years

DID YOU KNOW...

Kinkajous have reddish to golden-brown fur and are also often known as honeybears. They live primarily in trees and use their long tails (which, at approximately 15.7 in. (40 cm) in length, are almost as long as their bodies) to swing to more remote and inaccessible parts of trees to search for food. They can rotate their feet 180 degrees, a talent that enables them to climb up and down trees as fast backward as forward. These nocturnal animals also sleep in hollow tree trunks and are, therefore, seldom spotted on the ground. They have an extremely keen sense of hearing, with which they can even detect the slithering movements of snakes. They can also see in the dark. Kinkajous are normally solitary animals, socializing only to mate. Unlike other animals, however, they do not have fixed mating seasons. A kinkajou litter contains one to two babies, which remain with their mother until they are four months old. Although kinkajous look friendly, they can be decidedly aggressive if they feel threatened.

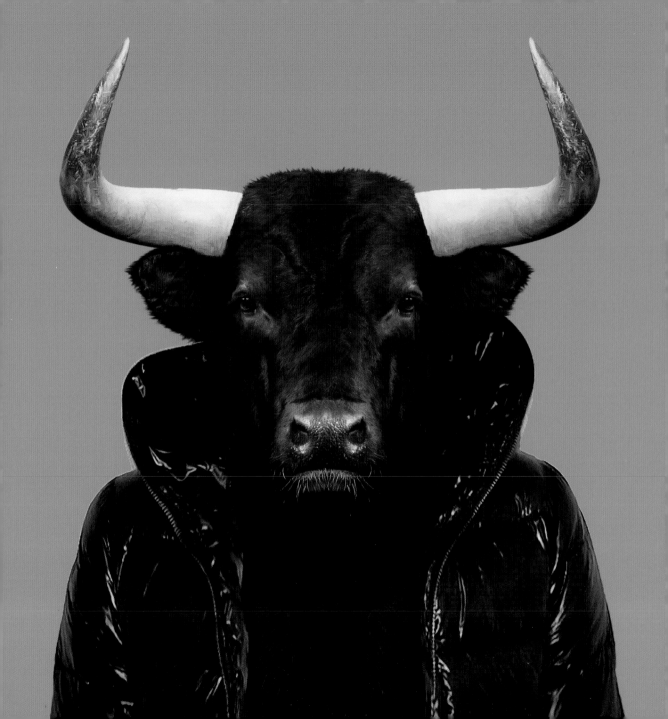

FERNANDO THE SPANISH FIGHTING BULL

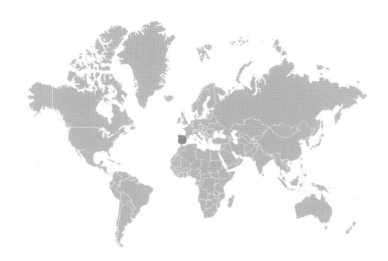

COMMON NAME
Spanish Fighting Bull

SCIENTIFIC NAME
Bos taurus ibéricus

CONSERVATION STATUS
Not Evaluated (NE)

POPULATION
Common

HABITAT
Pastures

SIZE / WEIGHT
⇪ 3.6–4.6 ft. (1.1–1.4m)
⇨ 8.2 ft. (2.5 m)
⚖ 600–1,000 lb. (272–454 kg)

GESTATION PERIOD
283 days

DIET
Grass

LIFE SPAN
Up to 20 years

DID YOU KNOW...

Spanish fighting bulls probably originated from European aurochs cattle. Although they are also used in milk and meat production, they are bred specifically for bullfighting. Spanish fighting bulls are closer to wild cattle in temperament than to our domestic cattle. They weigh up to 992 lb. (450 kg) and live, on average, around twenty years. When used for bullfighting, however, their life expectancy tends to be closer to just six years. In breeding these bulls, a process that began in the 15th and 16th centuries in the Spanish province of Valladolid, breeders look for a particular quality known as bravura, an innate aggressiveness. Spanish bulls come from various different bloodlines, such as the Navarra, Cabrera, Vazqueña, and Vistahermosa. Bulls destined for fighting are evaluated for trapío, a trait that comprises several different physical characteristics, behavioral traits, and reactions. Numerous animal rights organizations are currently battling to ban all bullfighting in Spain.

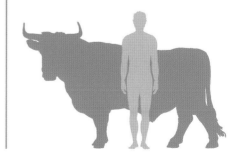

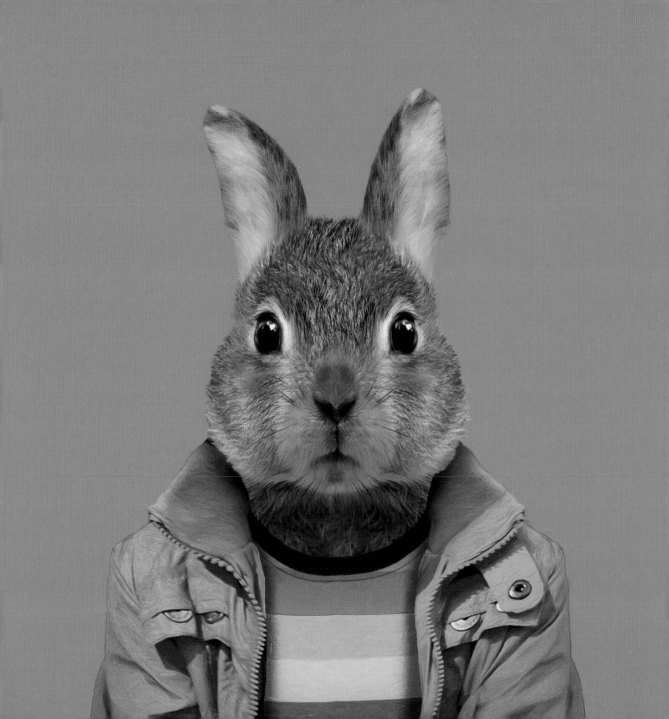

PEDRO THE EUROPEAN RABBIT

COMMON NAME
European rabbit

SCIENTIFIC NAME
Oryctolagus cuniculus

CONSERVATION STATUS
Nearly Threatened (NT)

POPULATION
Common

HABITAT
Dry plains, forests, undergrowth

SIZE / WEIGHT
⇨ 13–20 in. (34–50 cm)
🏋 2.4–5.5 lb. (1.1–2.5 kg)

GESTATION PERIOD
29–35 days

DIET
A variety of plants, including agricultural crops

LIFE SPAN
Up to 9 years

DID YOU KNOW...

The oldest fossil of a European rabbit dates from the end of the Pliocene Epoch. European rabbits are, therefore, the forerunners of all domestic rabbits living today. Their muscular hind legs enable them to jump distances of 9.8 ft. (3 m), and up to 3.3 ft. (1 m) in height, while their highly mobile eyes are positioned on the sides of their heads, giving them almost 360-degree vision. They live in colonies of up to 100 members in subterranean warrens containing numerous passages and chambers. Females can give birth to multiple litters each year, and they nurse their young inside a nesting burrow for approximately four weeks. During the 18th and 19th centuries, settlers introduced European rabbits to Australia. There, they had no natural predators or competition for food and their populations quickly reached plague proportions. Despite this, they are considered Near Threatened, a precursor to the "Threatened" category, as their populations in their original habitats (Spain and North Africa) have considerably decreased.

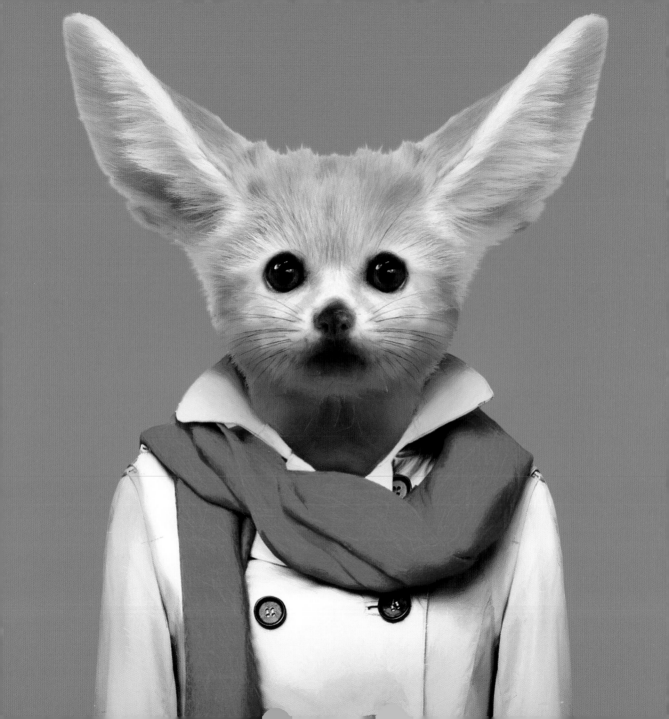

NABILA THE FENNEC FOX

DID YOU KNOW...

The fennec, or desert, fox is the world's smallest fox. It also has the largest ears of all fox species—and can rotate them to boot! Fennecs' ears and outstanding sense of hearing enable them to detect prey even underground. Their large ears also help to dissipate body heat. Fennec foxes have hair on their paws to protect them from the hot desert sand and to keep them warm at night. They live in small communities, mate for life, and give birth every year. Fennec communities live in a series of underground burrows and caves which they dig into the sand—preferably near a root system for stability. They are nocturnal hunters who never drink. Instead, they get their fluid requirements from their food (which includes plants, fruits, and animals) and their kidneys are adapted to desert life to enable them to store fluids in their bodies for long periods of time. Their main predators are eagle owls, but also include hyenas, jackals, and caracals. Fennecs can be domesticated.

COMMON NAME
Fennec fox

SCIENTIFIC NAME
Vulpes zerda

CONSERVATION STATUS
Least Concern (LC)

POPULATION
Common

HABITAT
Deserts and other extremely arid areas

SIZE / WEIGHT
⇨ 9–16 in. (24–41 cm)
🏋 1.5–3.5 lb. (0.68–1.59 kg)

GESTATION PERIOD
50–52 days

DIET
Plants, rodents, birds, eggs, and rabbits

LIFE SPAN
Up to 14 years

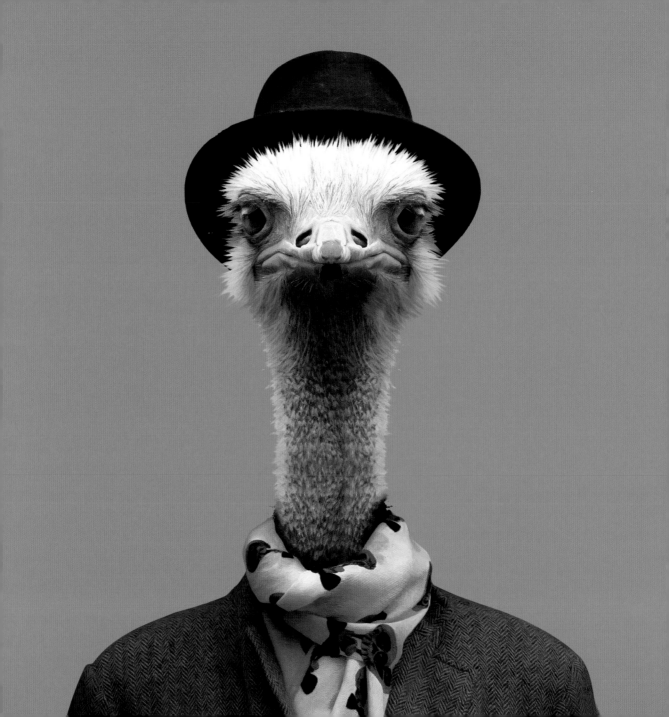

SAMMY THE OSTRICH

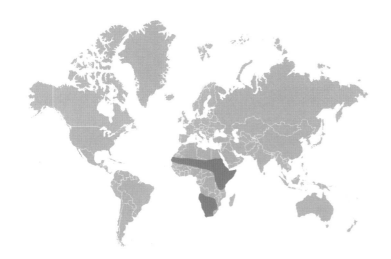

DID YOU KNOW...

Ostriches are the world's largest ratites. Unable to fly, they can run for up to 30 minutes at a time and reach speeds of up to 43.5 mph (70 km/h). In doing so, they use their wings (which have a span of approximately 6.6 ft. (2 m)) like airplane wings to change direction. They also flap them during mating rituals and use them to protect their young. Whereas ostriches spend the winter alone or in pairs, during the breeding season they form groups led by females. These groups mingle with herds of other species, such as zebras or antelope. Only one pair of ostriches in each group will babysit all the babies, which means that two birds can end up looking after up to 100 chicks. It is a myth that ostriches bury their heads in the sand when they sense danger. Instead, they either run away or defend themselves by kicking with their muscular legs and powerful claws. When faced with a threat during the mating season, they lie on the ground and stretch their heads and necks out flat in order to camouflage themselves. From a distance, this posture makes them look as though their heads are buried in the ground.

COMMON NAME
Common ostrich

SCIENTIFIC NAME
Struthio camelus

CONSERVATION STATUS
Least Concern (LC)

POPULATION
Common

HABITAT
Semiarid areas with wide temperature ranges (15–40°C)

SIZE / WEIGHT
⇧ ♀ 5.6–6.6 ft. (1.7–2.0 m)
⇧ ♂ 6.9–9.2 ft. (2.1–2.8 m)
⬛ 139–320 lb. (63–145 kg)

BROODING PERIOD
39–42 days

DIET
Plants, fruit, small animals, stones for digestion

LIFE SPAN
Up to 40 years

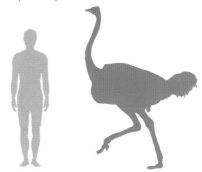

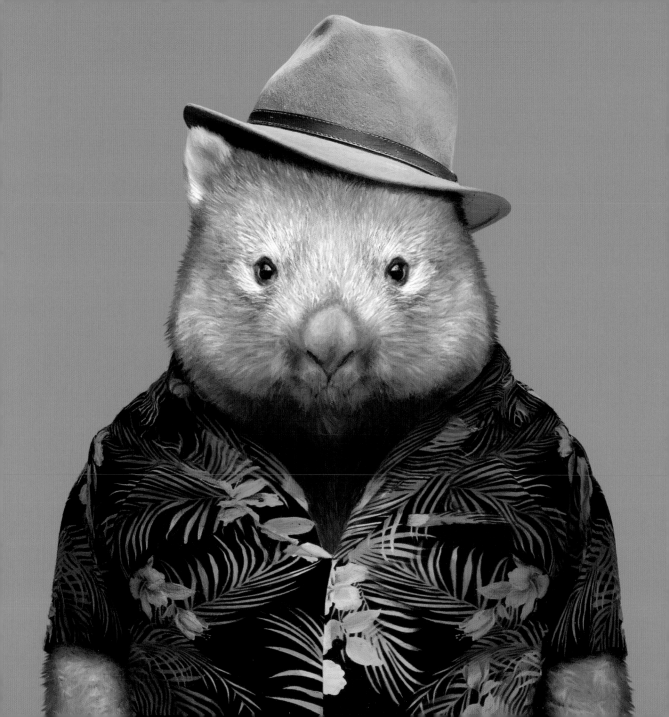

HENRY THE WOMBAT

COMMON NAME
Common wombat

SCIENTIFIC NAME
Vombatus ursinus

CONSERVATION STATUS
Least Concern (LC)

POPULATION
Common

HABITAT
Burrow systems in temperate forest, coastal scrub, and heathland areas

SIZE / WEIGHT
⇨ 33.1–45.3 in. (84–115 cm)
🏋 48.5–86 lb. (22–39 kg)

GESTATION PERIOD
20–30 days + 150–200 days in the bag

DIET
Grasses, sedges, and roots

LIFE SPAN
5 years in the wild,
up to 30 years in captivity

DID YOU KNOW...

Wombats are marsupials, and females carry their young in pouches on their bellies for around six months. These pouches face backwards, enabling pregnant females to use their strong claws and sharp teeth to dig burrows without showering their babies with dirt. Their burrows comprise large underground tunnel systems. If attacked directly, wombats can block the tunnel entrances with their hard rumps, which consist primarily of cartilage. If they are pursued, however, they flee into their burrows, where they collapse part of the tunnel system in order to bury their pursuers in debris. Wombats are herbivores and have very slow metabolisms, taking around 14 days to digest their food. Despite this—and despite their rather plump bodies and short legs—wombats can run at speeds of up to 25 mph (40 km/h). Wombat mating rituals last at least thirty minutes. During these rituals, the male runs in circles around the female, then rolls her onto her side and attempts to mount her. The female resists this initially, and the whole process begins again.

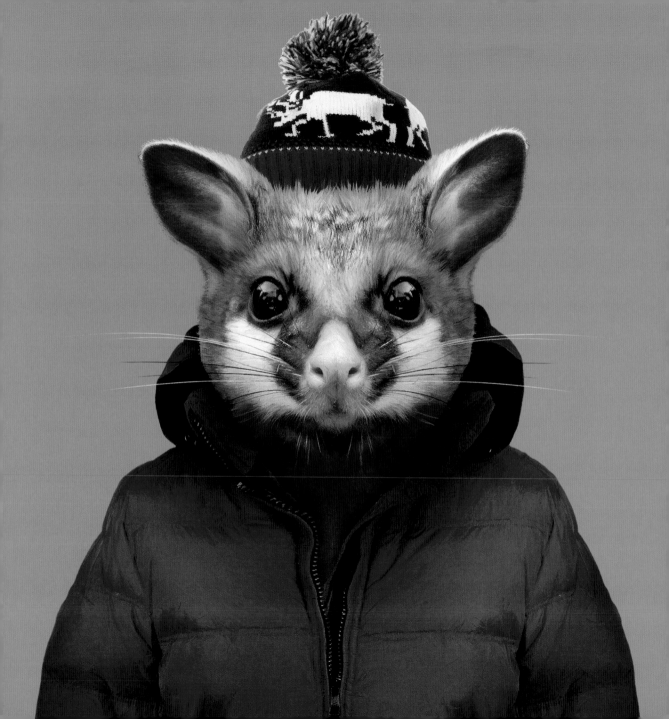

ARLO THE BRUSHTAIL POSSUM

DID YOU KNOW...

Common brushtail possums are the most common marsupials in Australia. The tips of their tails have no fur, which makes them useful for gripping branches and the twigs of the trees in which they live. Common brushtail possums are nocturnal and delineate their territories in the trees with a red, strongly-scented substance produced in glands on their chests. Common brushtail possums only congregate with others of their kind during mating season. They normally build their nests high in the tree crown, or in tree hollows. Like all marsupials, they are very small at birth (only a little over inch, or 1.5 cm), and they remain attached to the teats in their mothers' pouches for four to five months. Adult possums spend most of the day—44 percent of it, in fact—sleeping, 30 percent moving from one location to the next, 16 percent eating, and about 10 percent grooming themselves. When common brushtail possums were introduced to New Zealand, they multiplied so quickly that they were soon considered pests, threatening the local ecosystem. Since then, they have been exterminated like vermin there.

COMMON NAME
Common brushtail possum

SCIENTIFIC NAME
Trichosurus vulpecula

CONSERVATION STATUS
Least Concern (LC)

POPULATION
Common, declining

HABITAT
Various types of forests, preferably eucalyptus forests

SIZE / WEIGHT
⇨ ♀ 9.5–16 in. (24–40 cm)
⇨ ♂ 12.5–23 in. (32–58 cm)
⚖ 2.6–10 lb. (1.2–4.5 kg)

GESTATION PERIOD
16–18 days

DIET
Leaves, flowers, shoots, seeds, insects, eggs, small invertebrates

LIFE SPAN
up to 13 years the wild

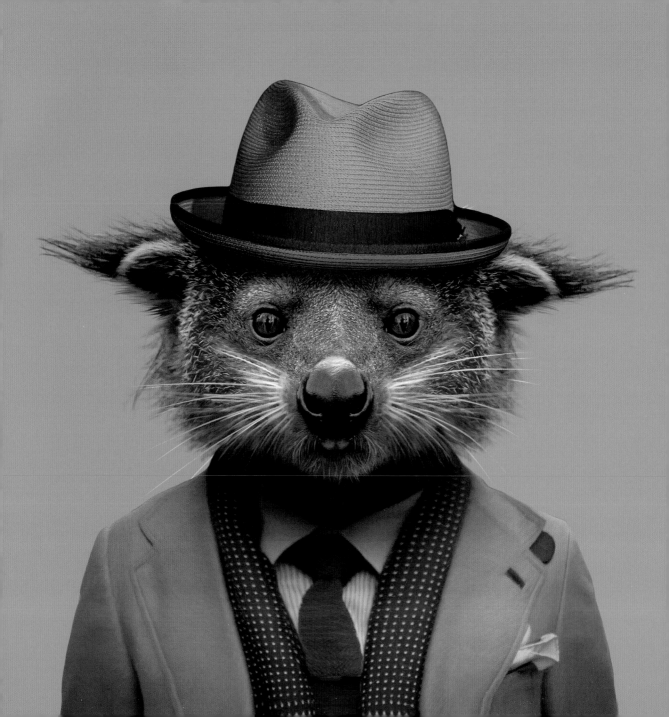

AGUNG THE BINTURONG

DID YOU KNOW...

Maybe the most striking trait of the lively binturong is their peculiar scent—like buttered popcorn!—which stems from a chemical substance in their urine. As they urinate, they wet their feet and tails, which then mark their territory as they move from branch to branch. Compared to the size of their bodies, their tails are extremely long at 10.5 in. (27 cm). Although they eat predominantly fruit, they are also carnivores. The binturong belongs to a group of only about 100 mammals that can use embryonic diapause, which means that females can delay the implantation of the fertilized zygote until the environmental conditions, such as temperature or safety, are ideal. Binturongs make many different sounds, ranging from a type of giggling when they are content to a hissing sound during hunting or mating. They also howl and growl when they feel threatened. The greatest threat to binturongs is the decimation of their habitat, which is caused by the construction of palm oil factories.

COMMON NAME
Binturong (or bearcat)

SCIENTIFIC NAME
Arctictis binturong

CONSERVATION STATUS
Vulnerable (VU)

POPULATION
Unknown, but constantly declining

HABITAT
In the canopy of forested areas, normally in tropical forests

SIZE / WEIGHT
⇨ 23.6–35.4 in. (60–90 cm)
🏋 19.8–44 lb. (9–20 kg)

GESTATION PERIOD
90–92 days

DIET
Fruit, especially figs; also insects, small birds, fish, and rodents

LIFE SPAN
18 years

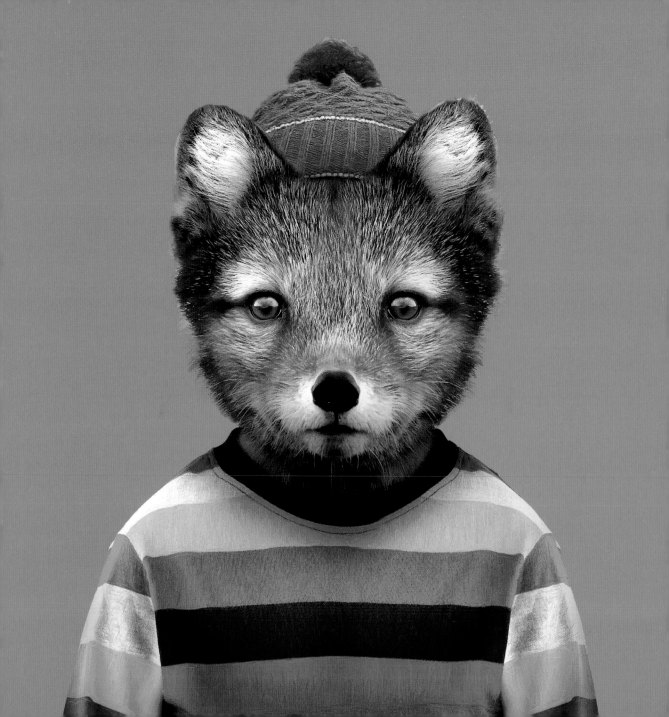

OTTO THE ARCTIC FOX

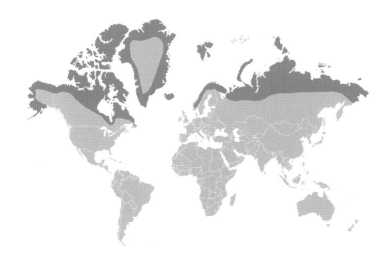

DID YOU KNOW...

Arctic foxes have such an excellent system for conserving body heat that they can withstand temperatures as low as -94°F (-70°C). They shed their very thick, white winter coats in the summer to reveal thinner, brown-to-cream-colored fur. For further protection against the winter cold, their ears are smaller and more rounded than those of other foxes, their muzzles are short, and the pads of their paws are covered in a thick layer of fur. Still, many young Arctic foxes do not survive their first winter because they haven't had a chance to build up an adequate layer of protective fat. Arctic foxes are solitary animals, living in underground tunnels that can be up to 1.3 miles (2 km) long and have multiple entrances. They hunt by jumping straight up in the air and then pouncing headfirst on their prey. In addition to being stalked by their natural enemies (wolverines, wolves, and eagles), Arctic foxes continue to be hunted by poachers for their winter coats. Red foxes, who are encroaching on more and more of the Arctic fox's habitat, also pose a threat.

COMMON NAME
Arctic fox

SCIENTIFIC NAME
Vulpes lagopus

CONSERVATION STATUS
Least Concern (LC)

POPULATION
Common

HABITAT
Arctic tundra regions

SIZE / WEIGHT
⇨ 16–27 in. (41–68 cm)
🏋 3.1–20.7 lb. (1.4–9.4 kg)

GESTATION PERIOD
52 days

DIET
Birds, small mammals (lemmings), birds' eggs, carrion

LIFE SPAN
3–6 years

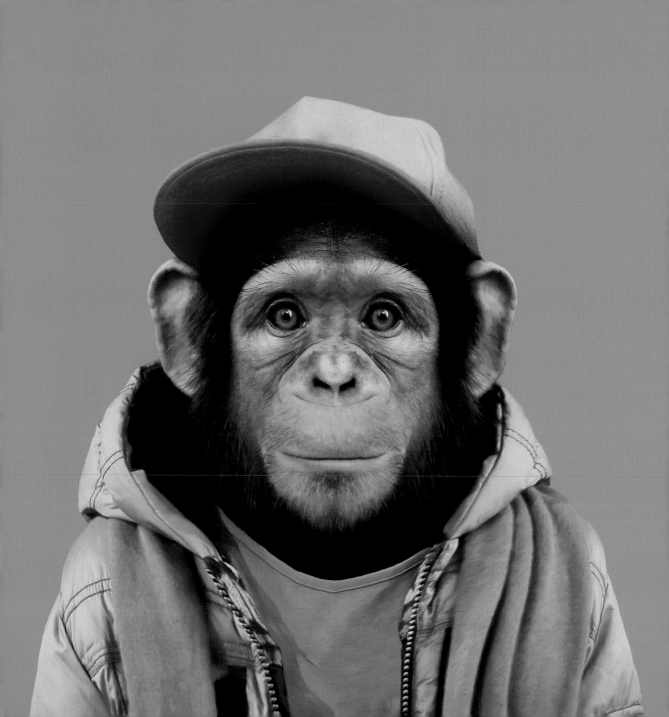

OUMAR THE CHIMPANZEE

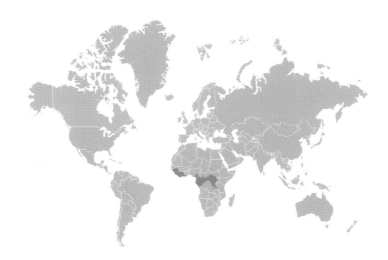

DID YOU KNOW...

Chimpanzees share around 95 percent of their DNA with humans. They live in groups of up to 120 individuals, within which their specific behaviors and particular methods of using tools are passed down from one generation to the next. Chimpanzees stay with their mothers until they are five years old. During this time, they learn everything they need to know to survive. They are not, however, accepted by the group as adults until they are around 13 years of age. Chimpanzees display clearly recognizable feelings: They express joy, pain, grief boredom, and even depression (following the loss of a mother, for example). They also hug and tickle each other, and are able to laugh. Some even use plants to heal wounds or to treat illnesses, such as intestinal worms. Although they cannot swim, they are stronger than humans and have better short-term memories. Their continued existence in the wild is threatened by the increasing destruction of their habitat by humans.

COMMON NAME
Common chimpanzee

SCIENTIFIC NAME
Pan troglodytes

CONSERVATION STATUS
Endangered (EN)

POPULATION
300,000 individuals

HABITAT
Tropical rainforests and wet savannas

SIZE / WEIGHT
⇧ ♀ 2–3.3 ft. (0.66–1 m)
⇧ ♂ 3–4 ft. (0.9–1.2 m)
⬛ ♀ 57–110 lb. (26–50 kg)
⬛ ♂ 90–115 lb. (35–70 kg)

GESTATION PERIOD
243 days

DIET
Fruit, leaves, insects, nuts, eggs, monkeys, and small animals

LIFE SPAN
35–40 years

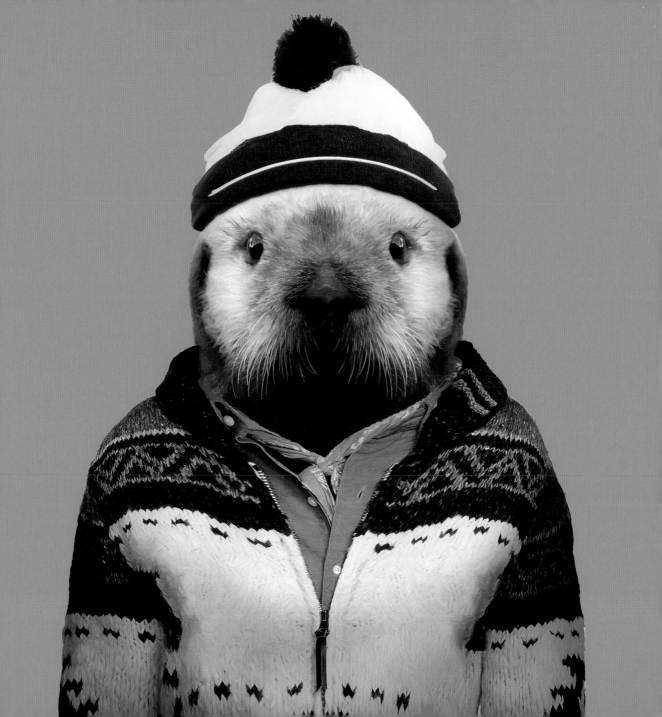

GOROU THE SEA OTTER

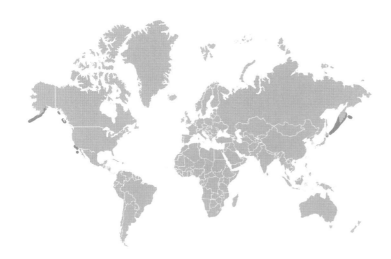

COMMON NAME
Sea otter

SCIENTIFIC NAME
Enhydra lutris

CONSERVATION STATUS
Endangered (EN)

POPULATION
106,000 individuals worldwide

HABITAT
Coastal waters 50–75 ft. (15–25 m) deep, approx. 0.6 miles (1 km) from shore

SIZE / WEIGHT
⇨ 3.2–5 ft. (1–1.5 m)
♀ 31–73 lb. (14–33 kg)
♂ 48–99 lb. (22–45 kg)

GESTATION PERIOD
122–365 days (delayed implantation)

DIET
Small animals from the ocean floor, primarily sea urchins

LIFE SPAN
10–20 years

DID YOU KNOW...

Sea otters almost died out until hunting them was banned in 1911. Before this, they were hunted for their silky fur, which is so thick that it even protects them against freezing water temperatures, despite the fact that, unlike other cold-water animals, they have no layer of subcutaneous fat. In order to keep their body temperature constant, they also eat approximately 25 to 40 percent of their own body weight in food per day. Sea otters live and sleep in the ocean, and can close their ears and nostrils to make them watertight. Their tremendous lung volume also enables them to remain underwater for several minutes. Males and females sleep in separate groups, numbering from ten to two thousand individuals. When doing this, they hold "hands" or wrap themselves in seaweed to prevent themselves from drifting apart. They belong to the few animals that use tools, such as stones, to open tough shells, and they use their front paws to catch fish and to hold them while they eat them. As their main source of food is sea urchins, which destroy kelp forests, sea otters play an important role in the ecosystem.

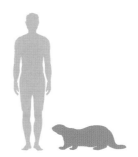

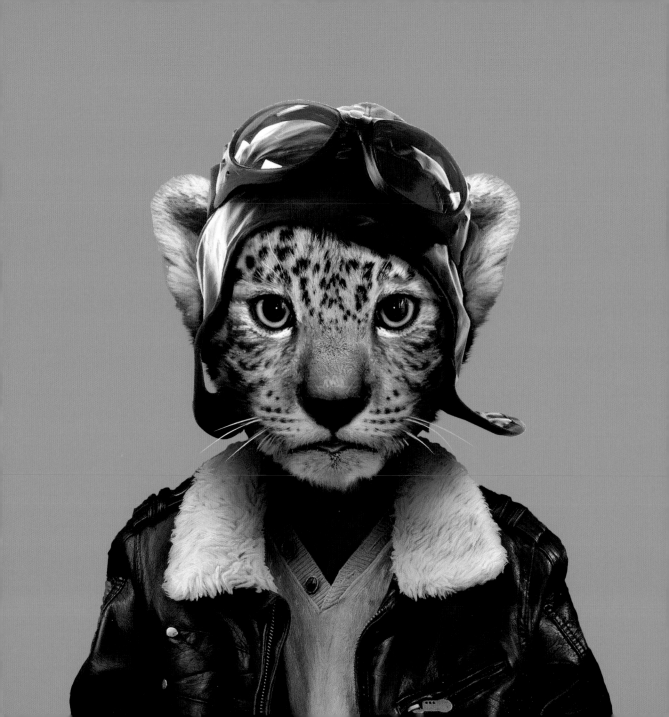

JEONG THE AMUR LEOPARD

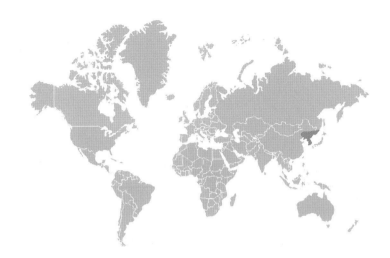

DID YOU KNOW...

The main difference between Amur leopards and other types of leopards is that Amur leopards' fur is much thicker and longer than that of other leopards. Amur leopards hunt during the first half of the night. They are very agile, capable of jumping up to 9.8 ft. (3 m) vertically and 19.6 ft. (6 m) horizontally, and of climbing down trees headfirst. They drag their kills—even when they are three times their own weight—up into trees to enjoy their meals undisturbed. For the most part, their water intake comes from their food. Except for mothers with their cubs, Amur leopards are solitary animals. This species is in danger of becoming extinct due both to poaching and, for quite some time, a complete lack of political motivation to protect them. Originally, they were well represented in the Korean islands and parts of China, but now there are only a few specimens living there. Recently, several species preservation programs have been created in Russia. An estimated 100 to 200 Amur leopards currently live in captivity, mainly in European and North American zoos and conservation facilities.

COMMON NAME
Amur leopard

SCIENTIFIC NAME
Panthera pardus orientalis

CONSERVATION STATUS
Critically Endangered (CR)

POPULATION
Only 35 individuals in the wild, 150 individuals in captivity

HABITAT
Taiga

SIZE / WEIGHT
⇑ 25–31 in. (64–78 cm)
⇒ 42–54 in. (107–136 cm)
◣ 55.1–105.8 lb. (25–48 kg)

GESTATION PERIOD
92–95 days

DIET
Hare and game

LIFE SPAN
Up to 21 years

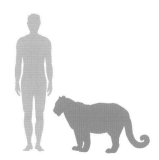

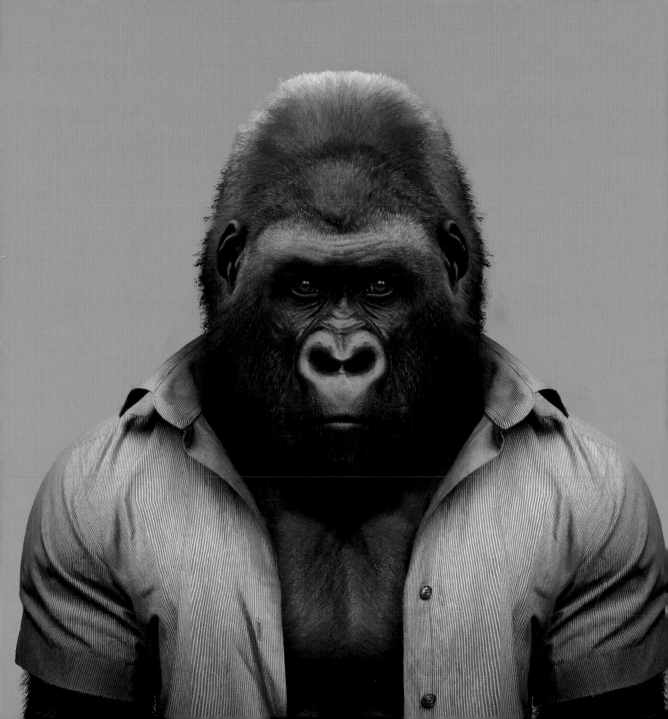

AWAX THE WESTERN LOWLAND GORILLA

COMMON NAME
Western lowland gorilla

SCIENTIFIC NAME
Gorilla gorilla gorilla

CONSERVATION STATUS
Critically Endangered (CR)

POPULATION
100,000 individuals

HABITAT
Primary and secondary forests
or lowland swamps

SIZE / WEIGHT
⇧ 3.9–5.9 ft. (1.2–1.8 m)
⚖ 149.9–399 lb. (68–181 kg)

GESTATION PERIOD
256 days

DIET
Roots, fruit and fruit pulp, wild celery,
plant stalks, tree bark

LIFE SPAN
Up to 35 years

DID YOU KNOW...

Western lowland gorillas are considered an endangered species, even though their population is a little larger than that of mountain gorillas. Western lowland gorillas have shorter hair and longer arms than their mountain relatives. Despite their formidable height of 4 to nearly 6 ft. (1.2 to 1.8 m), they are slightly smaller than mountain gorillas. Western lowland gorillas live in communes of about 30 members, led by one dominant male who, thanks to the gray hair on his back, is often dubbed a "silverback." The leader of the group not only organizes the daily routine of his troop, often leading them on long trips to find food, but also defends them remarkably aggressively. Western lowland gorillas are highly intelligent: They use tools to attain food, they use about 25 different sounds to communicate with one another and, in captivity, they have even learned to use a type of simplified sign language to communicate with humans. Their only natural predators are leopards and crocodiles.

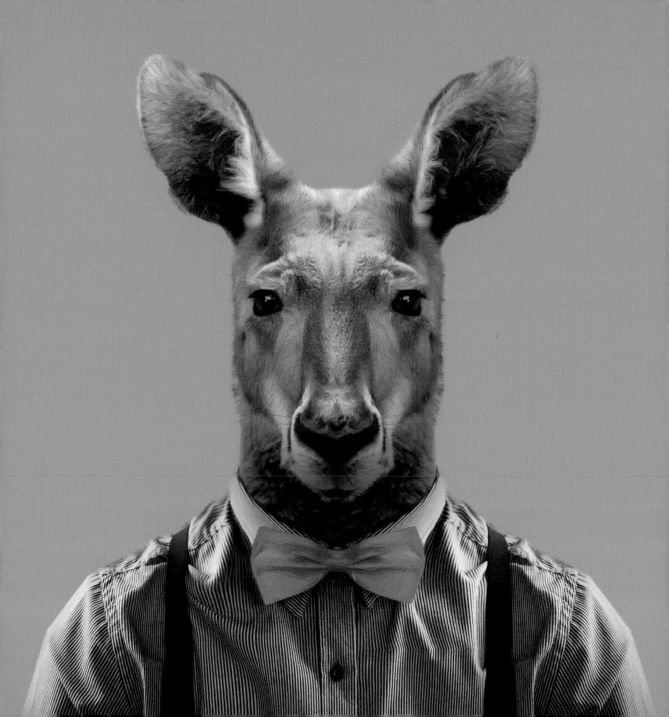

PETER THE RED KANGAROO

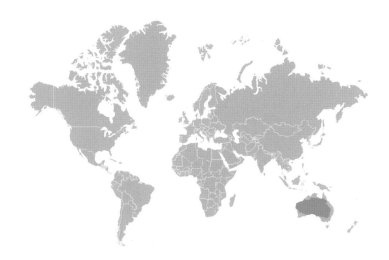

DID YOU KNOW...

The red kangaroo is the world's largest marsupial. Males grow to 5.2 ft. (1.60 m) tall with tails that are an additional 3.9 ft. (1.20 m) long, and females can be a little over 3.3 ft. (1 m) with tails an additional 2.8 ft. (85 cm) in length. They use their muscular tails to keep their balance and to push off the ground while hopping. In this way, they can reach hopping speeds of up to 37 mph (60 km/h). As with all kangaroo species, however, each pair of appendages—their front paws and their powerful hind legs—must move in concert; they cannot move independently. If a kangaroo wants to move forward slowly, it must place its short front paws on the ground for support. Kangaroos do not sweat. To cool themselves, they lick their paws and rub their chests. To help them recognize danger in time, kangaroos have a 300-degree field of vision and can rotate their large ears. The red kangaroo's birth and upbringing processes are the same as the grey kangaroo's. There is an unsubstantiated anecdote about how kangaroos got their name: Apparently, when explorer James Cook arrived in Australia and asked the indigenous people what these animals were called, the people responded with Ganguru, which simply means "I cannot understand you."

COMMON NAME
Red Kangaroo

SCIENTIFIC NAME
Macropus rufus

CONSERVATION STATUS
Least Concern (LC)

POPULATION
Very common

HABITAT
Deserts and open grassland in dry and semiarid regions

SIZE / WEIGHT
⇧ ♀ 3.3–3.9 ft. (1–1.2 m)
⇧ ♂ 4.3–5.2 ft. (1.3–1.6 m)
🏋 ♀ 40–88 lb. (18–40 kg)
🏋 ♂ 121–198 lb. (55–90 kg)

GESTATION PERIOD
33 days + 190 days in the bag

DIET
Grasses, flowers, leaves, ferns, moss, and sometimes insects

LIFE SPAN
16–22 years

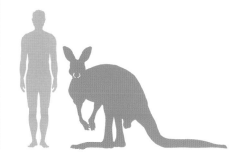

CAMILO THE RED-EYED TREE FROG

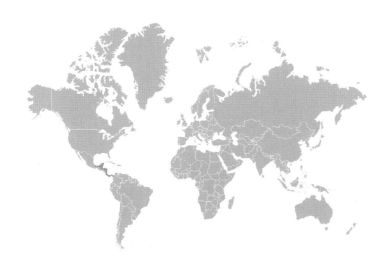

COMMON NAME
Red-eyed tree frog

SCIENTIFIC NAME
Agalychnis callidryas

CONSERVATION STATUS
Least Concern (LC)

POPULATION
Common

HABITAT
Tropical (rain)forests and lowlands, near bodies of water

SIZE / WEIGHT
⇨ ♀ 2.8 in. (7.1 cm) ♂ 2.2 in. (5.6 cm)
⚖ 0.2–0.5 oz. (6–15 g)

BROODING PERIOD
6–9 days

DIET
Insects

LIFE SPAN
3–5 years

DID YOU KNOW...

These little green frogs with the conspicuous red eyes spend their days stuck to the underside of large tree leaves, and their nights hunting. Their red eyes are designed to briefly distract potential attackers like birds, bats, and snakes—giving the frogs a moment to escape. During the mating season, the male frog launches himself onto the back of an approaching female and clings on. He often remains there for hours, until the female's eggs are fertilized. The female then sticks multiple clumps of spawn to higher-level leaves overhanging a pool. After approximately six to eight days, the tadpoles emerge and fall directly into the water. Following a metamorphosis of approximately eighty days, they migrate onto land as fully formed tree frogs. Although red-eyed tree frogs are not considered an endangered species, their habitats are threatened by climate change and the ongoing destruction of their environment. They are also threatened by their own attractiveness—increasingly, they are being captured and sold as pets.

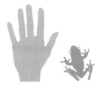

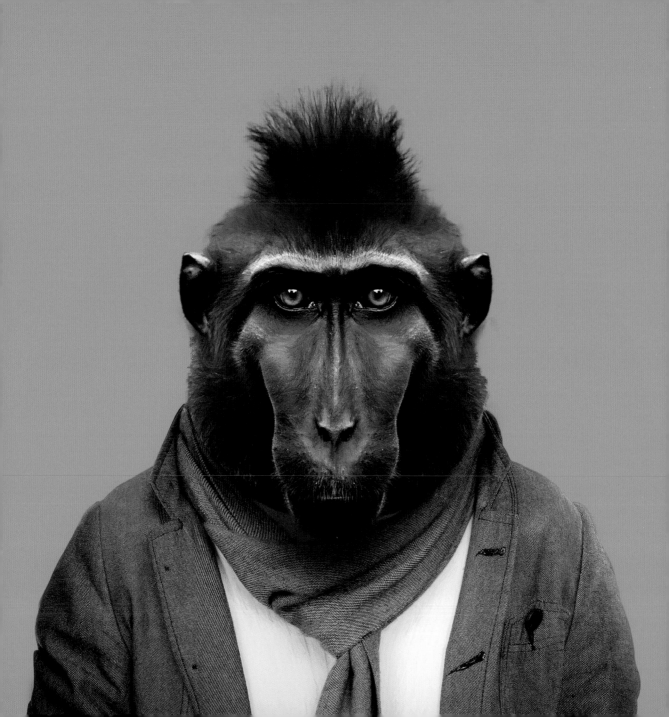

JAMES THE CRESTED BLACK MACAQUE

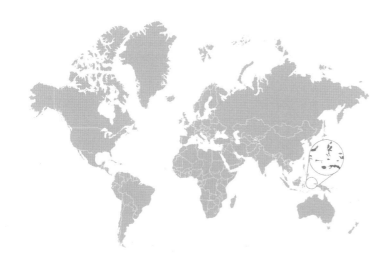

DID YOU KNOW...

Crested black macaques are the smallest monkeys in the genus Macaca. Their faces and bodies are completely jet black, except for a few white hairs at the shoulder. They have tufts of long hair, or crests, on the tops of their heads. They live exclusively in the Indonesian islands. Crested black macaques are diurnal and spend most of the day on the ground. At night, you can find them sleeping in the trees, where they also search for food. They live in groups of 20 to 100, with smaller groups containing only one male, while larger groups can contain up to four. Young males must leave their birth group when they reach puberty, at about four years of age. They either create their own exclusively male group or join another mixed group. Crested black macaques are listed as Critically Endangered, partially because the local inhabitants hate them and hunt them (because they destroy their crops), and partially because of the progressive deforestation of the rainforests.

COMMON NAME
Crested black macaque

SCIENTIFIC NAME
Macaca nigra

CONSERVATION STATUS
Critically Endangered (CR)

POPULATION
100,000 individuals

HABITAT
Tropical rainforests and moderate high plains

SIZE / WEIGHT
⚦ 17.3–23.6 in. (44–60 cm)
⚖ 7.9–22.9 lb. (3.6–10.4 kg)

GESTATION PERIOD
174 days

DIET
Primarily fruitarian, with occasional arthropods, young leaves, and twigs

LIFE SPAN
up to 18 years in the wild,
up to 34 years in captivity

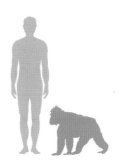

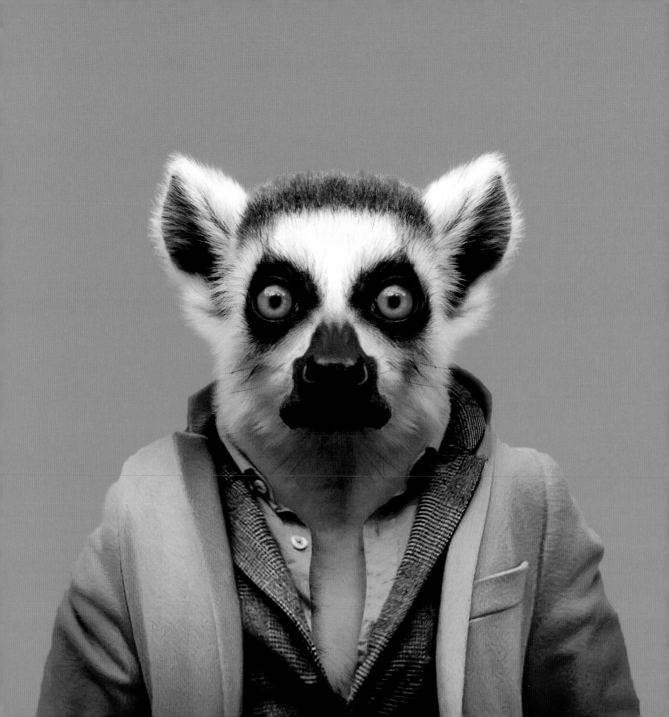

WESLEY THE RING-TAILED LEMUR

DID YOU KNOW...

This lemur species is named for its striking tail, which, at up to 25 in. (63 cm) long, is usually longer than the rest of its body. Lemurs mark their territories with strong-smelling secretions produced by scent glands near their wrists and, in males, also on their chests. They live in groups of 6 to 30, led by one dominant female and containing only one male capable of reproduction. Baby lemurs weigh about 3.5 oz. (100 g) at birth. During their first two weeks of life, babies are exclusively carried and nursed by their mothers. After that, they start eating solid food and walking on their own. Although lemurs are diurnal, they have superb night vision, thanks to a reflective coating behind their retinas. Lemurs are endangered primarily by the destruction of their habitat, but also because they live in areas with very poor human populations, who hunt them for food.

COMMON NAME
Ring-tailed lemur

SCIENTIFIC NAME
Lemur catta

CONSERVATION STATUS
Endangered (EN)

POPULATION
Unknown, declining

HABITAT
Madagascar: High-elevation forests surrounded by cliffs and ericoid savanna

SIZE / WEIGHT
⇨ 15–18 in. (39–46 cm)
🏋 4.9–7.7 lb. (2.2–3.5 kg)

GESTATION PERIOD
135–145 days

DIET
Especially fruit, tamarind tree leaves, flowers, bark, and sap

LIFE SPAN
Up to 18 years

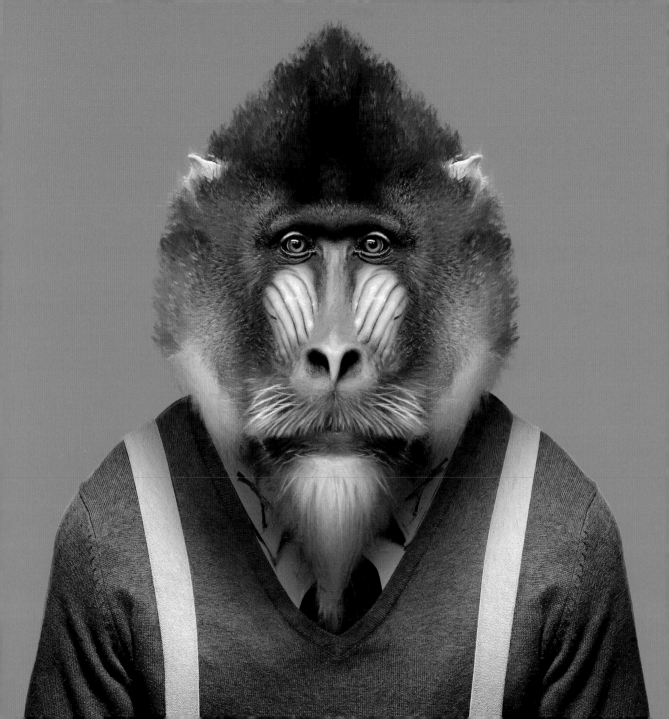

BENI THE MANDRILL

DID YOU KNOW...

Mandrills are primarily conspicuous for their brightly colored faces and rumps, whereby those of the males, who also have yellow beards and large canine teeth, are considerably more obvious. Female mandrills live in groups (known as "hordes") of up to 1000, headed by a dominant male. Male mandrills that do not have a horde to lead live alone, but join the horde temporarily during the mating season. Mandrills communicate using scent markings, gestures, and sounds. The males' large canine teeth are designed to intimidate and impress others during the mating season, as well as to scare off attackers. Like other primate species, mandrills are extremely intelligent and use tools: One film made by a British scientist even shows a mandrill cleaning his toenails with a peeled twig. Mandrills are currently a protected species and are threatened by deforestation and poaching.

COMMON NAME
Mandrill

SCIENTIFIC NAME
Mandrillus sphinx

CONSERVATION STATUS
Vulnerable (VU)

POPULATION
Unknown

HABITAT
Evergreen tropical rainforests and mountain forests

SIZE / WEIGHT
⇧ ♀ 22–26 in. (55–66 cm)
⇧ ♂ 30–37 in. (75–95 cm)
⚖ ♀ 22–33 lb. (10–15 kg)
⚖ ♂ 42–82 lb. (19–37 kg)

GESTATION PERIOD
175 days

DIET
Fruit, leaves, roots, insects, fungi, and seeds

LIFE SPAN
Up to 20 years

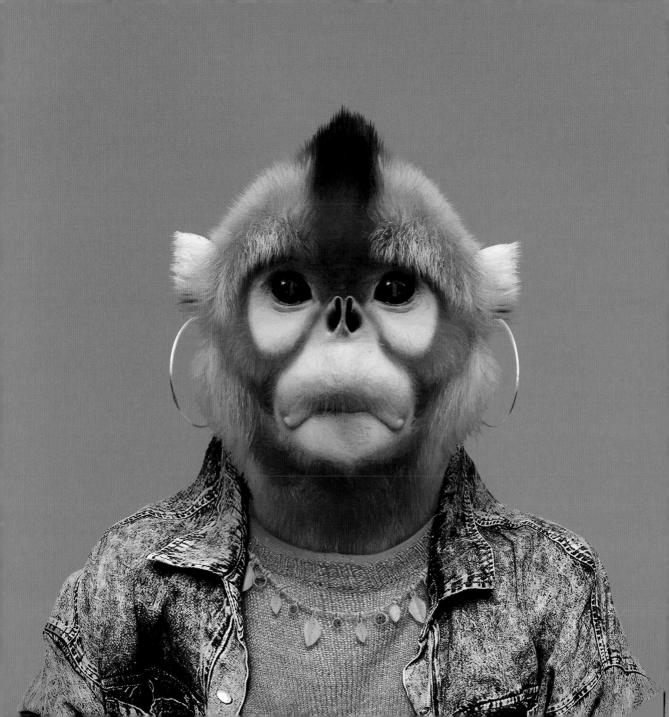

HUI THE GOLDEN SNUB-NOSED MONKEY

DID YOU KNOW...

This species of colobine primate owes its name to its short nose, a mutation adapted to the cold temperatures in the mountainous regions of China. For the same reason, the snub-nosed monkey's entire body, with the exception of its mouth, nose, and eyes, is covered with thick hair. These monkeys' exposed faces usually have a blue hue, a very rare characteristic in mammals. The males are somewhat larger than the females, their fur appears more golden, and their front teeth are longer. Like many monkeys, golden snub-nosed monkeys live in families of one male and multiple females. These join with other families to form troops of up to 200. They are Old World monkeys, which is shown (among other things) by the fact that they spend most of their time on the ground, seated on their rumps. Females generally give birth to one baby per year, which spends five months being nursed by its mother, as well as by other mothers in the group. Unfortunately, golden snub-nosed monkeys are a threatened species because their pelts have long been considered a cure for rheumatism.

COMMON NAME
Golden snub-nosed monkey

SCIENTIFIC NAME
Rhinopithecus roxellana

CONSERVATION STATUS
Endangered (EN)

POPULATION
Less than 6,000 individuals

HABITAT
Forests above 1,400 MASL
and below 3,500 MASL

SIZE / WEIGHT
⇧ 22.4–30 in. (57–76 cm)
♀ 14.3–22 lb. (6.5–10 kg)
♂ 33–86 lb. (15–39 kg)

GESTATION PERIOD
174–208 days

DIET
Bark, seeds, shoots, leaves, insects, and fruit in seasonal rotation

LIFE SPAN
Up to 20 years

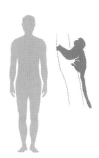

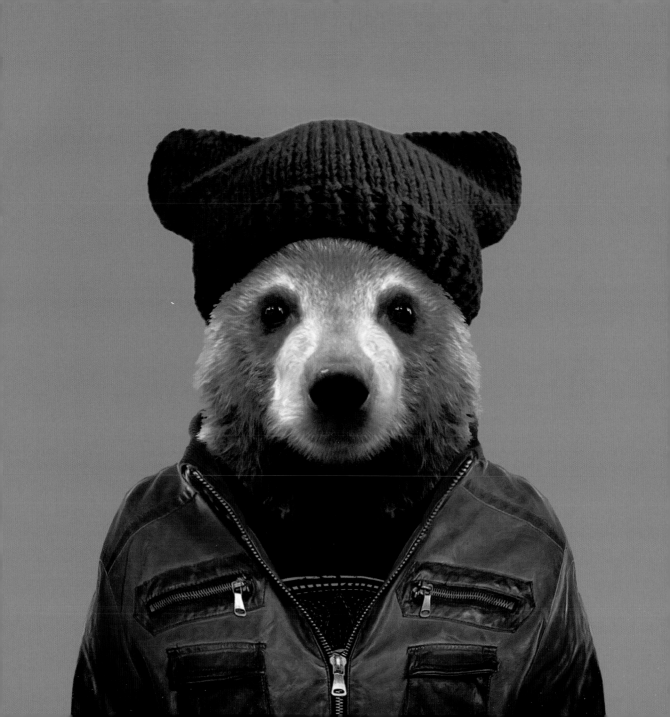

JACOB THE KODIAK BEAR

COMMON NAME
Kodiak bear

SCIENTIFIC NAME
Ursus arctos middendorffi

CONSERVATION STATUS
Least Concern (LC)

POPULATION
3,500 individuals

HABITAT
Mountains, forests, bays,
and wetlands of Alaska

SIZE / WEIGHT
⇧ 4.9 ft. (1.5 m)
⇨ 9.8 ft. (3 m)
♀ 253–794 lb. (115–360 kg)
♂ 661–1,322 lb. (300–600 kg)

GESTATION PERIOD
180–270 days
(incl. delayed implantation)

DIET
Salmon, meat, roots, shoots, and fruit

LIFE SPAN
Up to 20 years

DID YOU KNOW...

The largest subspecies of brown bear, Kodiak bears have lived predominantly in the Kodiak National Wildlife Refuge since 1941. This refuge was created on the Alaskan island of Kodiak specifically for the protection of the Kodiak bear. For the most part, these bears are solitary (except for mothers with cubs), though they can also live in groups if there is a sufficient supply of food, and have devised a complex social communication system for doing so. Despite their weight, they can sprint as fast as 34.7 mph (56 km/h), and are good swimmers. They have no natural enemies except for humans. However, adult males often kill their own cubs in order to mate with the females again. At birth, Kodiak cubs are very small, blind, and have only a thin covering of fur, and need four to five months before they are strong enough to be more independent. The hibernation period for most Kodiaks is between October and May. During this time, they sleep without eating, drinking or eliminating, and wake up having lost just a small amount of muscle mass.

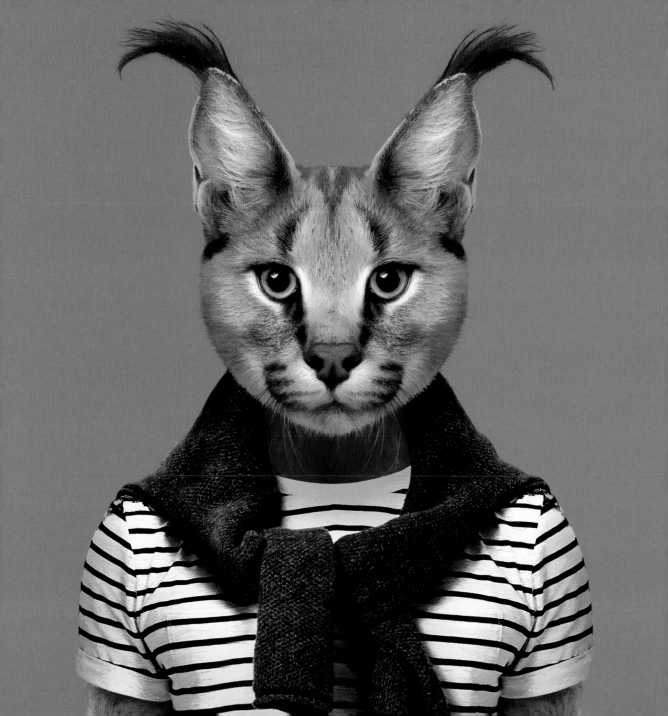

ÀBAKAR THE CARACAL

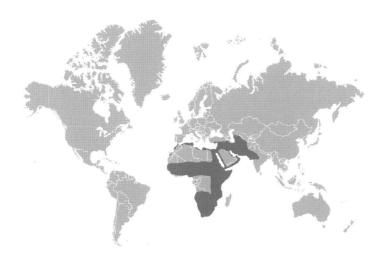

DID YOU KNOW...

The caracal, whose name comes from the Turkish word karakulak, meaning "black ears," is also known as the African lynx. Caracals' closest relatives are not lynxes, however, but servals, another type of African wild cat. The most noticeable characteristics of these nocturnal animals are their large, moveable ears, which they can move in any direction to detect prey or impending danger quickly. Caracals can jump up to 9.8 ft. (3 m) in the air to reach birds, even when they have already taken flight. Usually, caracals prey on animals that are smaller than they are. In rare cases, however, they may attack a larger animal and then hide their kill in their den so that they can continue eating later. Caracals live alone or in pairs, and have between three and six kittens per litter. Incidentally, caracals were domesticated in ancient Egypt because they could be easily tamed by humans and used for hunting.

COMMON NAME
Caracal

SCIENTIFIC NAME
Caracal caracal

CONSERVATION STATUS
Least Concern (LC)

POPULATION
Unknown

HABITAT
Savanna, forest, semidesert, and flat marshland

SIZE / WEIGHT
⇨ 16–20 in. (40–50 cm)
⚖ 18–40 lb. (8–18 kg)

GESTATION PERIOD
68–81 days

DIET
Birds, hares, rodents, hyraxes, small monkeys, and antelope calves

LIFE SPAN
12–20 years

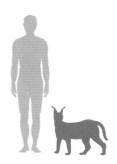

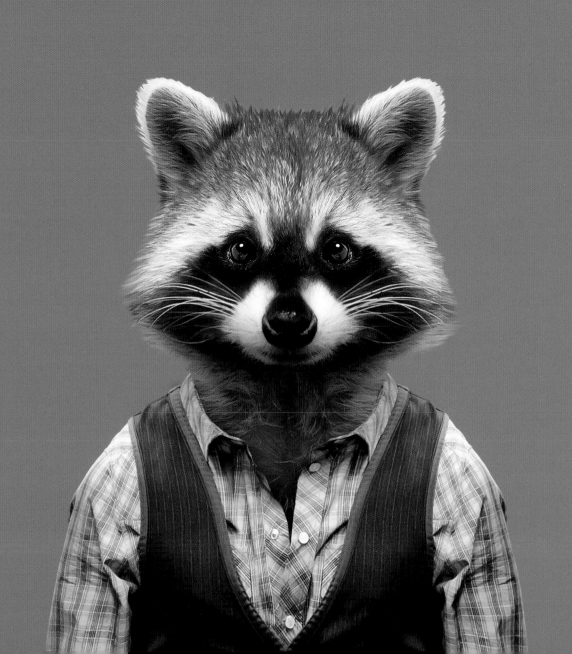

RASCAL THE RACCOON

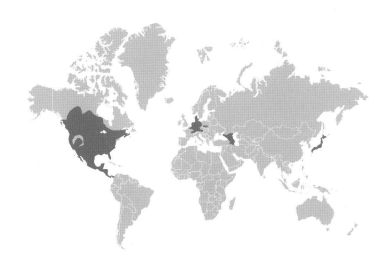

DID YOU KNOW...

The name "raccoon" has its origins in the Native American word aroughcoune, which means approximately "he who scratches with his hands." Indeed, raccoons examine their food very carefully with the five highly sensitive fingers on their front paws before eating it. Sometimes they also wash it in water. Although their short legs enable them to achieve maximum speeds of "only" 14.9 mph (24 km/h), they can scale trees incredibly fast. To climb back down, which they do headfirst, they can rotate their back feet 180 degrees. They are also very good swimmers, capable of spending hours in the water. Numerous behavioral studies indicate that raccoons have outstanding memories—they can, for example, remember solutions to tasks they completed three years before. Raccoons can make around 50 different sounds, including purrs, growls, squeaks, whistles, and hisses. They are also flexible enough to survive falls of more than 33 ft. (10 m).

COMMON NAME
Common raccoon

SCIENTIFIC NAME
Procyon lotor

CONSERVATION STATUS
Least Concern (LC)

POPULATION
Common

HABITAT
Mixed and deciduous forests, urban areas

SIZE / WEIGHT
⇨ 8.7–11.8 in. (22–30 cm)
🏋 4–23 lb. (1.8–10.4 kg)

GESTATION PERIOD
65 days

DIET
Fruit, vegetables, nuts, insects, rodents, frogs, eggs, crayfish, scraps

LIFE SPAN
2–3 years in the wild

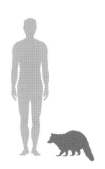

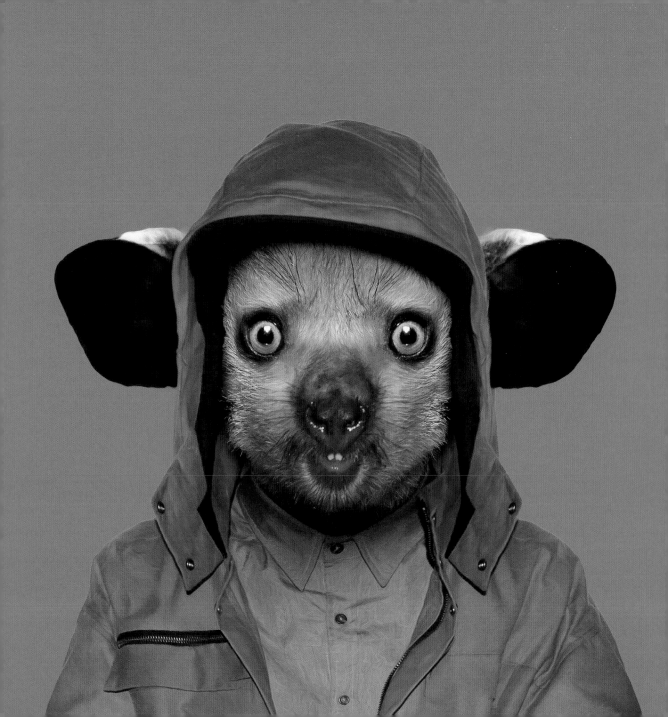

STAN THE AYE-AYE

COMMON NAME
Aye-aye

SCIENTIFIC NAME
Daubentonia madagascariensis

CONSERVATION STATUS
Endangered (EN)

POPULATION
Unknown, but decreasing

HABITAT
Treetops in tropical forests

SIZE / WEIGHT
⇨ 14.2–17.3 in. (36–44 cm)
⚖ 4.4–6.6 lb. (2–3 kg)

GESTATION PERIOD
152–172 days

DIET
Fruit, insect larvae

LIFE SPAN
Up to 23 years

DID YOU KNOW...

Aye-ayes are the largest nocturnal primates and are related to the lemur family. They live in trees, where they sleep in nests made of dry leaves and twigs. The middle finger of each hand is considerably thinner and longer than their other fingers, and they use it to tap on the bark of trees before deploying their excellent sense of hearing (amplified by their large ears) to detect insects beneath the bark. They then crack open the bark using their incisors (which, like those of rodents, grow continuously) and extract larvae and insects with their long middle fingers. They also use this technique with coconuts and fruit, in order to get at the coconut milk or fruit pulp. Except during the mating season, they live harmoniously together. The Madagascan people believe that aye-ayes are possessed by evil spirits and can curse people by pointing at them with their middle fingers, and many aye-ayes are killed due to this superstitious fear. Hunting and habitat destruction have caused aye-ayes to become an endangered species.

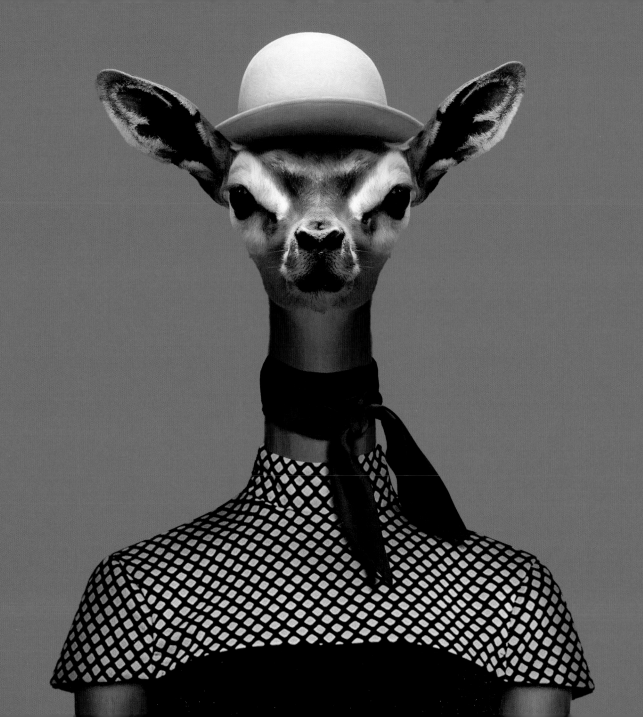

HANI THE GIRAFFE GAZELLE

DID YOU KNOW...

The giraffe gazelle is also known as the gerenuk, a name derived from the Somali word for "long-necked". This long neck supports a small head with gigantic ears. Only the males have horns and what are known as pre-orbital glands. These glands secrete a tar-like substance, which males use to mark their territory. Groups of females and their young will live together, as will groups of male "bachelors," but some males will lead completely solitary lives. Giraffe gazelles are a good example of animals adapting to their environment: They have learned to stand on their hind legs to reach high leaves and twigs that their competitors cannot. Young animals are able to do this at just two weeks old. Another notable characteristic is the fact that giraffe gazelles never drink. Instead, they absorb all the fluids they need through their food. Females are fertile all year round and babies can walk soon after being born. Although giraffe gazelles are well adapted for survival, their popularity as hunting trophies makes them an endangered species.

COMMON NAME
Gerenuk or giraffe gazelle

SCIENTIFIC NAME
Litocranius walleri

CONSERVATION STATUS
Nearly Threatened (NT)

POPULATION
95,000 individuals

HABITAT
Semiarid areas with woody vegetation and brush

SIZE / WEIGHT
⇪ 2.6–4.9 ft. (0.8–1 m)
⇨ 4.6–5.2 ft. (1.4–1.6 cm)
⚖ 62–115 lb. (28–52 kg)

GESTATION PERIOD
165 days

DIET
Foliage of medium-height bushes

LIFE SPAN
8–13 years

107

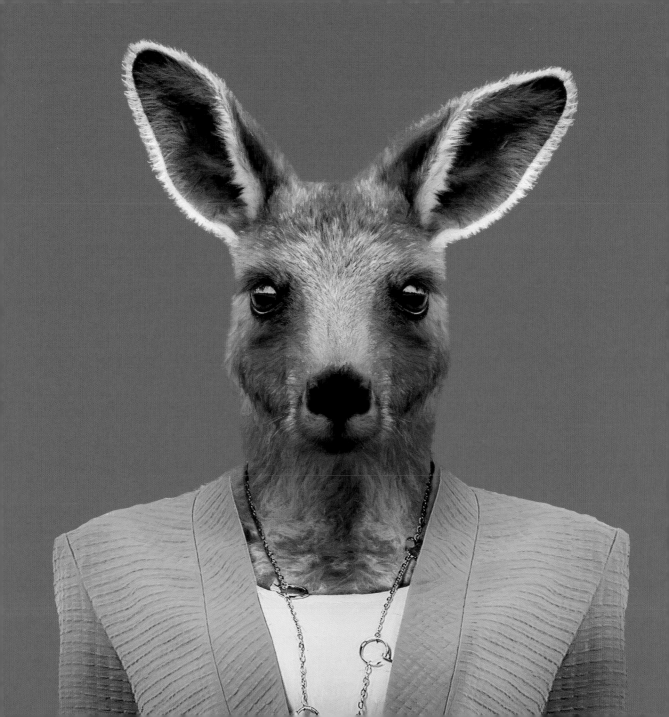

OLIVIA THE EASTERN GREY KANGAROO

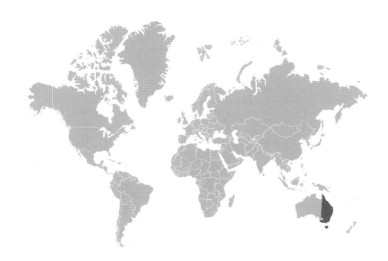

DID YOU KNOW...

The grey kangaroo is the second largest kangaroo species, after the red kangaroo. To avoid the heat of the day, kangaroos eat mostly at night. Their strong back legs allow them to spring effortlessly, reach speeds of up to 39 mph (64 km/h), and jump as far as 29.5 ft. (9 m) in a single bound. They cannot move backward, however. These marsupials live in mixed groups of up to 20. During the mating season, males often challenge one another to fights, during which they stand on their long tails and use their back legs to kick and scratch their opponents. They may also bite one another. For the first 36 days, kangaroo embryos develop in an incubation area of the birth canal. When they reach three-quarters of an inch (2 cm) in size, the young kangaroos, also called "joeys" in Australia, crawl into their mothers' pouches, where they spend the next 283 days. Sometimes, when one joey is developing in its mother's pouch, another embryo is formed. In this situation, the mother can pause the development of the embryo in the birth canal until the older joey leaves the pouch.

COMMON NAME
Eastern grey kangaroo

SCIENTIFIC NAME
Macropus giganteus

CONSERVATION STATUS
Least Concern (LC)

POPULATION
Between 10,000 and 20,000 individuals

HABITAT
Open grassland areas near brush

SIZE / WEIGHT
⇡ 2.7–4.3 ft. (0.84–1.3 m)
⚖ ♀ 37.5–88.1 lb. (17–40 kg)
⚖ ♂ 110.2–145.5 lb. (50–66 kg)

GESTATION PERIOD
36 days + 330 days in the bag

DIET
Various types of grass

LIFE SPAN
8–10 years in the wild

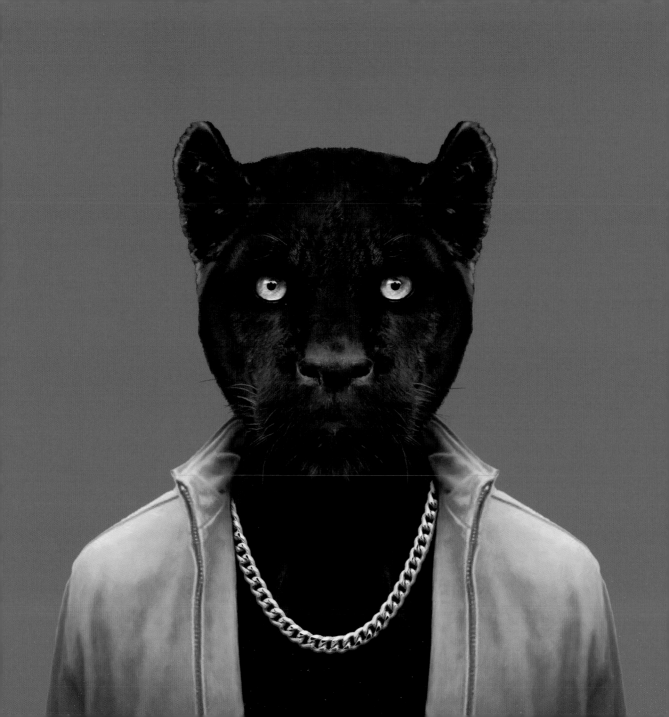

CESAR THE BLACK PANTHER

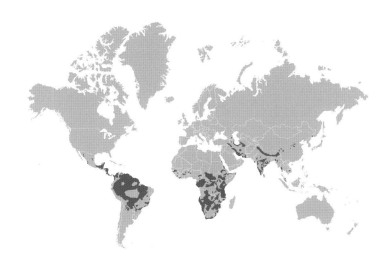

DID YOU KNOW...

Black panthers are not actually a species in their own right; instead, they are a color variation of jaguars and leopards. This black variation is caused by a genetic mutation that produces a large amount of melanin. (The opposite genetic variant produces albinos.) Leopards are found in Africa and Southeast Asia, whereas jaguars live in Central and South America. The different rosette patterns on their fur can be seen in bright light, even in the black variations of these species. Jaguars' spots are larger and more finely detailed than those of leopards. The two species of black panther also differ as much in their physical appearance as their golden relatives do, with jaguars being stronger and heavier than leopards, with shorter tails. Jaguars are considered good swimmers and enjoy cooling off in water. Leopards can also swim, and will enter the water while hunting. Both black panthers and black jaguars prefer to keep to the dark forest, where their midnight-black coloring gives them camouflage. Outside the mating season, all panthers, which are nocturnal, prefer to live and hunt alone. Black jaguars, which are the largest wildcat species in Central and South America, can even use their teeth and powerful jaw muscles to crush the skulls of their prey. Jaguars have no natural enemies in their habitat, whereas leopards do. The latter, whose slimmer build makes them better climbers than the stockier jaguars, also drag their kills up into trees in order to conceal them from other big cats.

COMMON NAME
Black panther

SCIENTIFIC NAME
Panthera pardus / Panthera onca

CONSERVATION STATUS
Vulnerable VU / Nearly Threatened (NT)

POPULATION
Unknown

HABITAT
Humid and semihumid areas,
like (rain)forests and open fields

SIZE / WEIGHT
Leopard ⇧ 1.6–2.1 ft. (0.5–0.65 m)
⇨ 3.6–4.9 ft.(1.1–1.5 m)
�largeweight 66–198 lb. (30–90 kg)
Jaguar ⇧ 62.1–2.4 ft. (0.65–0.75 m)
⇨ 3.3–6.2 ft. (1–1.9 m)
▰ 99–220 lb. (45–100 kg)

GESTATION PERIOD
Leopard 90–105 / Jaguar 93–105 days

DIET
Antelope, wild boar, rabbits

LIFE SPAN 12–15 years in the wild

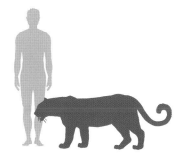

TOOH THE SOUTHERN CASSOWARY

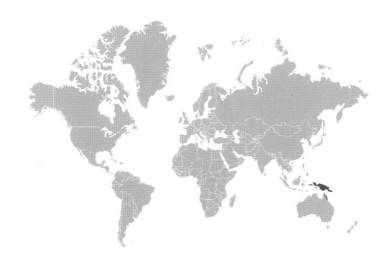

DID YOU KNOW...

After ostriches, cassowaries are the second-largest birds in the world—and the most dangerous. They use their strong legs and large claws to defend themselves quickly and vehemently. They can run as fast as 31 mph (50 km/h), jump nearly 6.5 ft. (2 m) high, and even swim. They cannot, however, defend themselves against the humans clearing the rainforests, and they are therefore classed as Vulnerable (VU) on the IUCN Red List of Threatened Species™. Their colorful neck and head plumage can change colors depending on their mood. Their bodies are covered in black, fur-like feathers and they have rigid crests, or casques, on their heads. These crests are made of keratin and become larger as they age. Their purpose is not completely understood. Southern cassowaries can make some of the lowest sounds in the bird kingdom. As the frequency of these tones is just under the audible level for humans, we perceive them only as vibrations. Female cassowaries lay between three and eight eggs, which are then incubated by the males for 50 days.

COMMON NAME
Southern cassowary

SCIENTIFIC NAME
Casuarius casuarius

CONSERVATION STATUS
Vulnerable (VU)

POPULATION
6,000–15,000 individuals

HABITAT
Rainforests, savanna, marshlands, and fruit plantations

SIZE / WEIGHT
⇡ 4.3–5.6 ft. (1.3–1.7 m)
♀ 128.9 lb. (58.5 kg)
♂ 63.9–74.9 lb. (29–34 kg)

BROODING PERIOD
47–54 days

DIET
Fruit (especially plums), leaves, fungi, insects, and small animals

LIFE SPAN
Up to 60 years

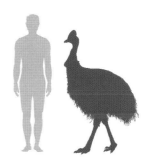

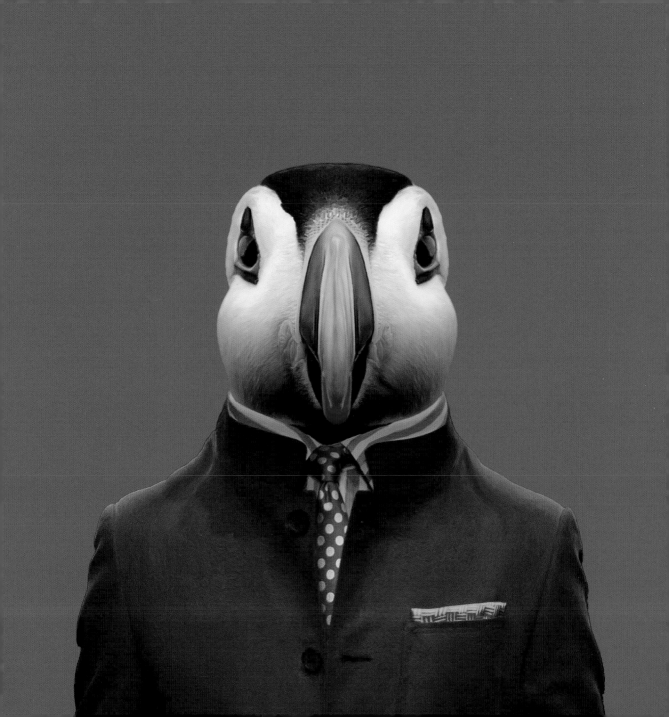

ALEK THE PUFFIN

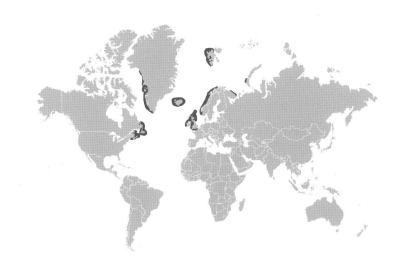

DID YOU KNOW...

Puffins, which belong to the genus Lunda, are monogamous and mate for life. During the breeding season, the pairs join huge colonies, but the rest of the time, they break away in pairs. Their beaks, which are brightly colored in summer, have earned them the nickname "sea parrot." Most of the time, puffins are at sea. They are excellent swimmers and divers and use their wings to propel themselves underwater. They can dive to a depth of 197 ft. (60 m) and stay underwater for up to 30 seconds. In the air, their wings beat up to 400 times per minute, and they can reach speeds of 56 mph (90 km/h) in flight. On land, however, the birds are comparatively clumsy and are slightly reminiscent of penguins. Their greatest natural enemies are other birds during the breeding season. For this reason, they defend their nests very aggressively. Their young leave the nest when they are between 34 and 50 days old and fly to the sea, where they live alone for the next two to three years before returning to land to mate. The number of grooves on their beaks is an indication of their age: At age 25, the maximum 4 grooves appear.

COMMON NAME
Atlantic puffin

SCIENTIFIC NAME
Fratercula arctica

CONSERVATION STATUS
Vulnerable (VU)

POPULATION
4,770,000–5,780,000 pairs

HABITAT
Coastal regions

SIZE / WEIGHT
⇧ 11–11.8 in. (28–30 cm)
⚖ 1.1 lb. (500 g)

BROODING PERIOD
42–45 days

DIET
Fish; sometimes crustaceans and worms

LIFE SPAN
Up to 20 years

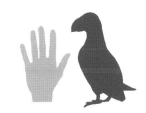

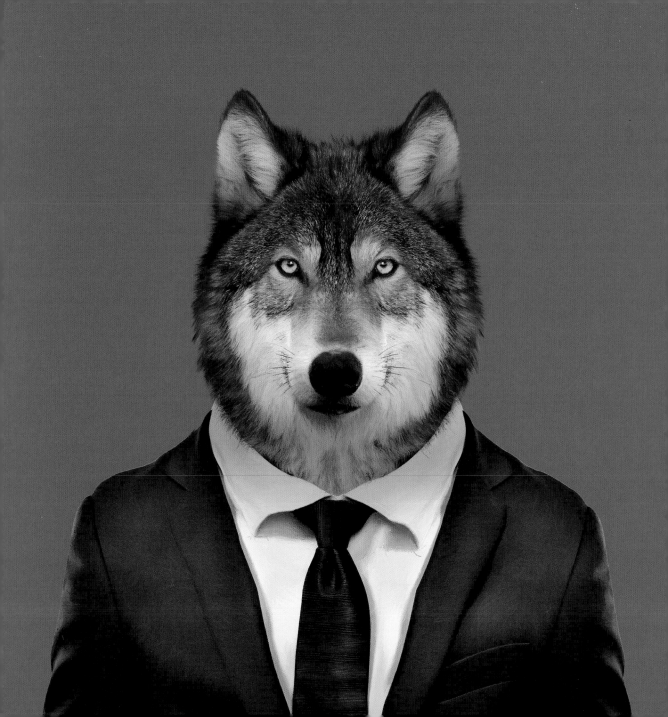

COLTON THE GRAY WOLF

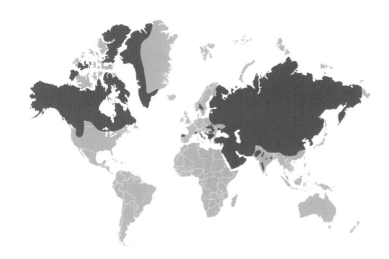

DID YOU KNOW...

Wolves are the world's largest canine predators. They live in family groups called packs. Only the alpha pair produces young, feeding them on food that they have pre-chewed (a trait they share with birds). Wolves are outstanding pack hunters, tending to hunt mainly in groups of four to six. They are, however, also great opportunists. They always select the easiest or weakest prey, and will not hesitate to attack members of their own species who are injured or caught in traps. Their priority is purely to eat. Wolves are not particularly fast, but they are extremely determined when it comes to stalking their prey, and will pursue their quarry for hours if necessary. If a wolf is cast out from the pack, he or she will seldom find a new one—hence the phrase "lone wolf". Wolves are a threatened species because their food supplies have been considerably reduced by the encroachment of human settlements. Wolves are also killed by humans protecting their livestock.

COMMON NAME
Gray wolf

SCIENTIFIC NAME
Canis lupus

CONSERVATION STATUS
Least Concern (LC)

POPULATION
Common

HABITAT
Deserts, grasslands, forests, and arctic tundra of the Northern Hemisphere

SIZE / WEIGHT
⇧ 31–33 in. (80–85 cm)
⇨ 41–63 in. (105–160 cm)
🏋 ♀ 79–85 lb. (36–38.5 kg)
🏋 ♂ 95–99 lb. (43–45 kg)

GESTATION PERIOD
62–75 days

DIET
Elk, deer, caribou, beavers, rabbits

LIFE SPAN
5–6 years

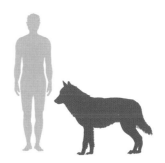

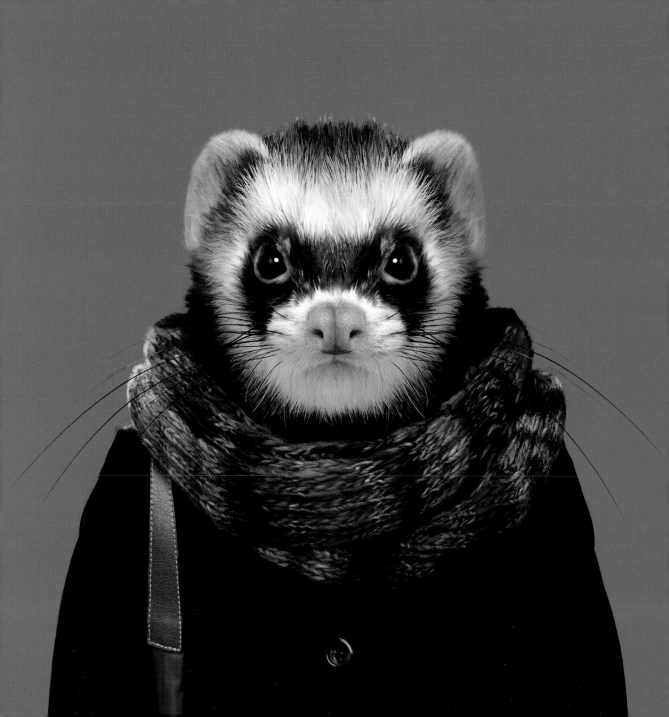

DEE THE FERRET

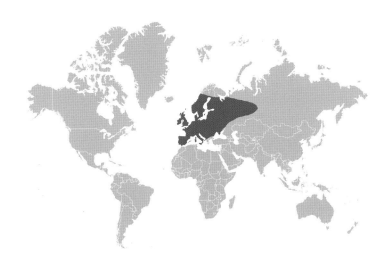

DID YOU KNOW...

Ferrets are the domesticated subspecies of polecats, and members of the Mustelidae family. They were probably first tamed by the Romans in order to control pests—or were worshipped like cats in Ancient Egypt. These small, strong animals have quite a pungent odor, particularly when they feel threatened. Their tendency to sleep with the tips of their tongues sticking out, however, makes them look simply adorable—and they sleep for about 18 hours a day. When awake, they love to run around and to hide—and to take an item or two with them. They are great collectors of objects, a trait which gave them their Latin name furo, meaning "thief." Ferrets produce two to three litters per year, with each litter containing seven to ten kits. One of the reasons they were exported to New Zealand was in order to bring the (also imported) population of European hares under control. Unfortunately, the ferrets also preyed on a number of native bird species. As a result, keeping ferrets is currently prohibited in New Zealand.

COMMON NAME
Ferret

SCIENTIFIC NAME
Mustela putorius furo

CONSERVATION STATUS
Not Evaluated (NE)

POPULATION
Common

HABITAT
Forrests / domestic environments

SIZE / WEIGHT
⇨ 20 in. (51 cm)
⚖ 1.5–4 lb. (0.7–2 kg)

GESTATION PERIOD
42 days

DIET
In the wild, small animals, but as pets, specially formulated food

LIFE SPAN
7–10 years

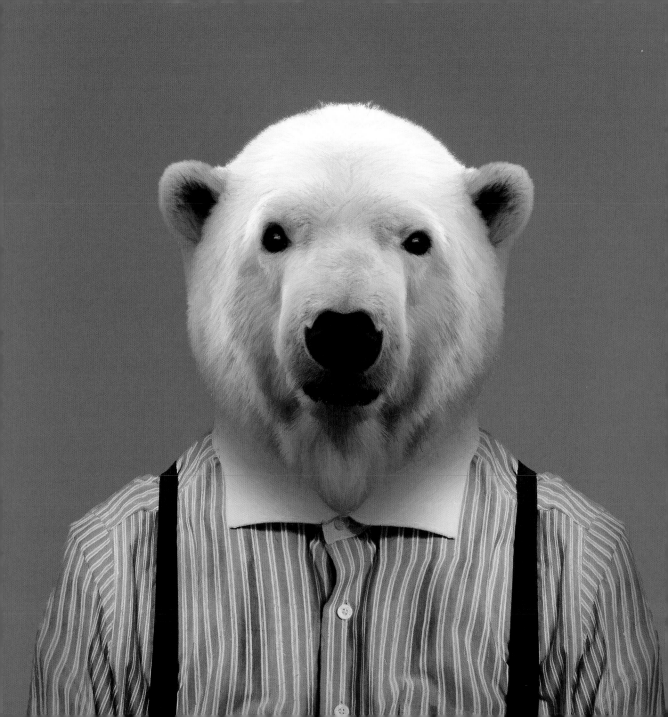

SAKARI THE POLAR BEAR

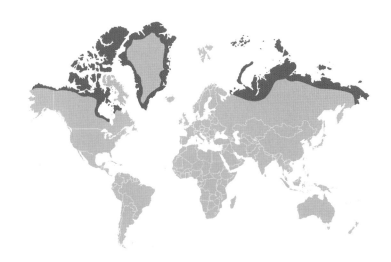

DID YOU KNOW...

Polar bears are descended from brown bears and are the largest land predators in the world. They are at the top of the food chain in their habitat and eat as much as 66 lb. (30 kg) of meat per day. They have a layer of fat 4.3 in. (11 cm) thick and a dense coat that repels water, both of which protect them from the icy cold of their environment (temperatures fall to -22°F/-30°C in winter), especially while hunting in water. Their fur appears white, but is actually made up of transparent, hollow hairs. Under their fur, their skin is black. This optimizes absorption of the sun's rays, both producing and storing heat. The soles of their feet and their claws are very large, rough, and partially covered with fur, enabling them to keep their balance on snow and ice. Polar bears are extremely solitary, except for mothers, who stay with their offspring for around two or three years. Polar bears may wander for thousands of miles when the seasons change and the search for food makes it necessary to do so. Similarly, if they are hunting, searching for a partner, or simply looking for a new ice floe during the spring thaw, they may swim up to 427 miles (687 km) without stopping.

COMMON NAME
Polar bear

SCIENTIFIC NAME
Ursus maritimus

CONSERVATION STATUS
Vulnerable (VU)

POPULATION
26,000 individuals

HABITAT
Cold regions near the sea with ice floes

SIZE / WEIGHT
⇧ 3.3–5 ft. (1–1.5 m)
⇨ 7.2–8 ft. (2.2–2.5 m)
♀ 386–772 lb. (175–350 kg)
♂ 772–1,543 lb. (350–700 kg)

GESTATION PERIOD
60 days, 195–265 days (delayed implantation)

DIET
Arctic animals; normally reindeer and seals

LIFE SPAN
25–30 years

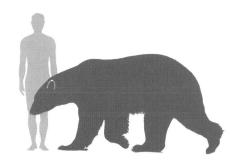

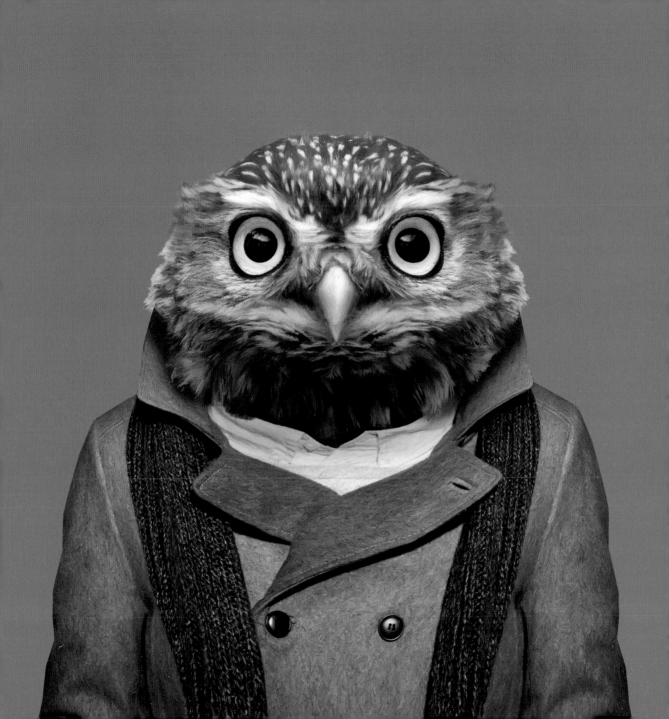

ALFIE THE LITTLE OWL

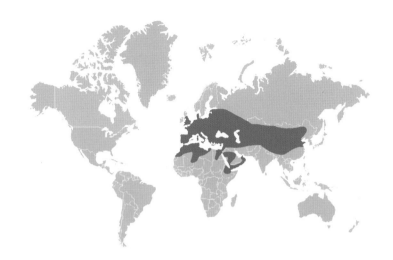

COMMON NAME
Little owl

SCIENTIFIC NAME
Athene noctua

CONSERVATION STATUS
Least Concern (LC)

POPULATION
10 million individuals

HABITAT
Holes in trees or burrows
in flatland areas

SIZE / WEIGHT
⇧ 8.7 in. (22 cm)
⚖ 6.3 oz. (180 g)

BROODING PERIOD
22–30 days

DIET
Small vertebrates, larger invertebrates,
insects, mollusks, crustaceans

LIFE SPAN
4 years in the wild,
15 years in captivity

DID YOU KNOW...

With an average height of around 8.7 in. (22 cm), the little owl is one of the smaller owl species. In contrast to other types of owl, little owls do not have ear tufts, and their facial disks are moderate in size. Little owls are found throughout Europe, in West Africa, on the Arabian Peninsula, and in parts of Asia. The species was even introduced to New Zealand at the beginning of the 20th century. Little owls are monogamous, and pairs stay together until one partner dies. Pairs spend their entire lives in the same area, and one of the male's jobs is to defend this territory. Females incubate their eggs in nests built in hollow tree trunks (but will also use pre-made nesting boxes). The males hunt on their own during the breeding season, a practice that continues until the chicks are bigger. At the age of around seven weeks, the chicks leave the nest. Although little owls tend to be nocturnal, they can sometimes be spotted in the daytime, sitting motionless on fences or on small trees in open areas, watching their prey.

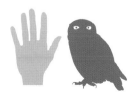

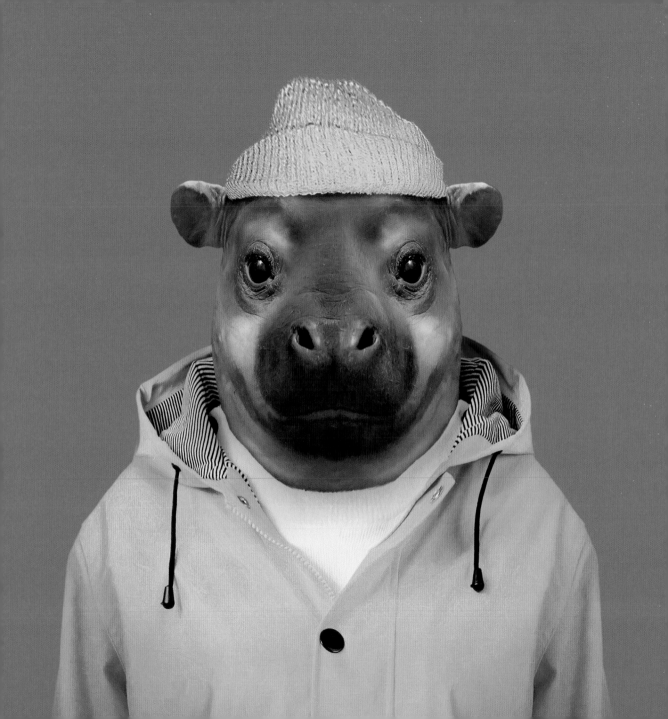

TITUS THE PYGMY HIPPOPOTAMUS

DID YOU KNOW...

There are two subspecies of hippo: pygmy hippopotamuses (397–606 lb. / 180–275 kg) and common hippopotamuses (up to 3,968 lb. / 1,800 kg). All hippos are nocturnal and spend their days in the water, a practice which also helps to protect their sensitive skin from the sun. At night, they graze on land. Pygmy hippos' skin exudes a reddish-colored, waterproof, and antiseptic secretion, which acts like a protective film. Due to its pinkish hue, people once believed that hippos sweated blood. Hippos can use strong muscles to seal their eyes and ears closed when they dive underwater. Although they are herbivores, they may open their mouths wide—as wide as 150–180 degrees!—to look more imposing and intimidating when necessary. This species is threatened by the reduction of their habitats in favor of farmland and plantations, as well as by poaching and by natural predators, such as leopards, pythons, and crocodiles. They are also under threat due to wars in their native lands. Surprisingly, hippos are closely related to whales.

COMMON NAME
Pygmy hippopotamus

SCIENTIFIC NAME
Choeropsis liberiensis

CONSERVATION STATUS
Endangered (EN)

POPULATION
2,000–3,000 individuals

HABITAT
Riparian forests and swamps in West Africa

SIZE / WEIGHT
⇧ 2.5–3.3 ft. (0.75–1 m)
⇨ 4.9–5.7 ft. (1.5–1.7 m)
⬛ 397–606 lb. (180–275 kg)

GESTATION PERIOD
190–210 days

DIET
Ferns, plants, and fruit

LIFE SPAN
30–55 years

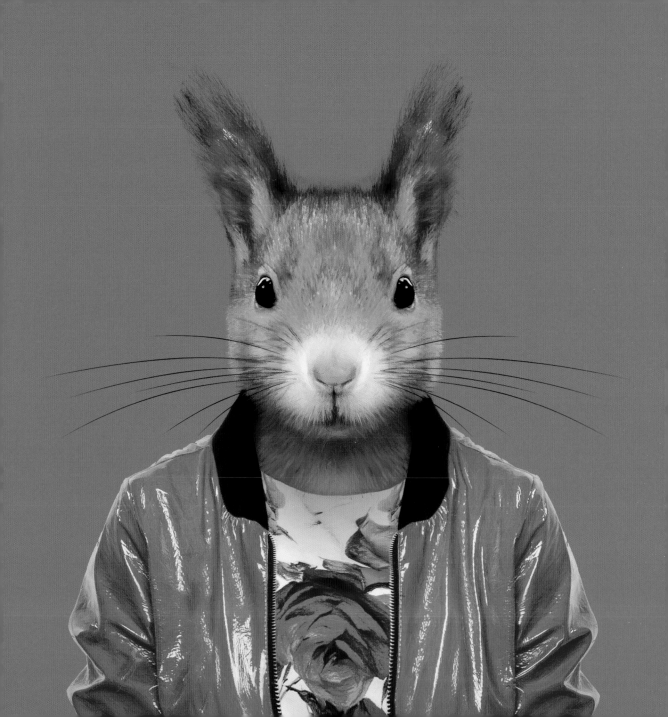

SAIJA THE RED SQUIRREL

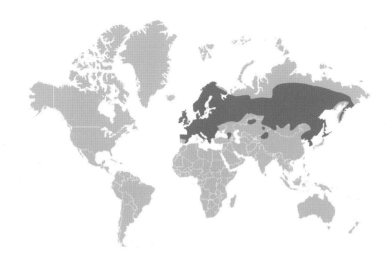

COMMON NAME
Red squirrel

SCIENTIFIC NAME
Sciurus vulgaris

CONSERVATION STATUS
Least Concern (LC)

POPULATION
Common

HABITAT
Various tree species

SIZE / WEIGHT
⇨ 17.5–9 in. (19–23 cm)
🪨 8.8–12 oz. (250–340 g)

GESTATION PERIOD
38–40 days

DIET
Seeds, fungi, nuts, berries, and shoots

LIFE SPAN
3–10 years

DID YOU KNOW...

Squirrels' fur ranges in color from light red to dark brown (almost black). The fur on their bellies is clearly delineated from the fur on their backs, and is white or cream-colored. Their winter coats are considerably thicker than their summer coats. In winter, their fur often becomes darker, and can also take on a grayish hue. Fur also grows on the otherwise hairless soles of their feet. They live mainly in trees, where they can move around at lightning speed and even climb down headfirst, thanks to their front feet, which have four clawed fingers and a thumb, and their five-toed hind feet. They can jump distances of up to 6.6 ft. (2 m) between trees and even survive falls from almost 40 ft. (12 m) unharmed. They use their long tails (which, at nearly 8 in. (20 cm) in length, are almost as long as their bodies), to keep their balance, and deploy them as rudders when jumping. Squirrels always build more than one nest in order to have a backup if the first one is discovered by predators or becomes infested with parasites. Red squirrels differ from American gray squirrels in more than just physical features: They have different tolerances for different kinds of nuts, for example, and are susceptible to different diseases. The two species cannot, therefore, interbreed.

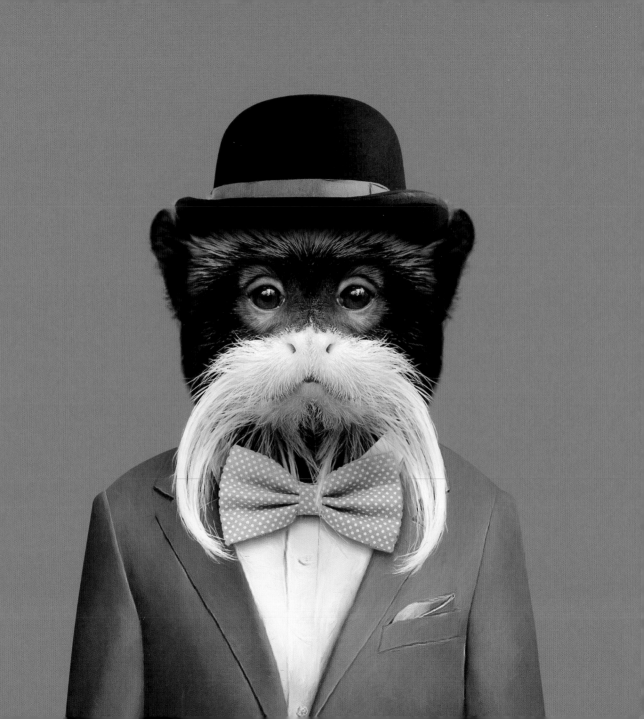

EDWIN THE EMPEROR TAMARIN

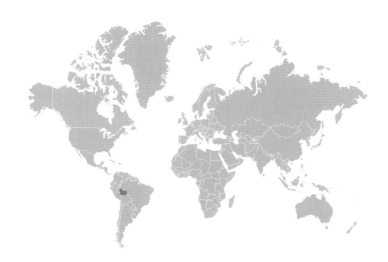

DID YOU KNOW...

It was the mustache of the German emperor Wilhelm II that gave this tamarin (a type of callitrichid) its name. Initially suggested as a joke, it later became the official name for these small monkeys with their long, non-prehensile tails. Emperor tamarins are approximately 9.8 in. (25 cm) tall, while their tails can reach 16.5 in. (42 cm) in length. Both males and females have prominent white mustaches that extend past their shoulders. Emperor tamarins are omnivores and are primarily tree-dwelling. Whereas the males can only see in black and white, around two-thirds of females can see three colors, allowing them to identify ripe fruit more easily. The males' black-and-white vision, on the other hand, helps them to spot camouflaged enemies. Emperor tamarins are very active, social animals. They enjoy playing with others and love being petted. They live in groups of up to eight members, primarily males, which are led by a single female. Young tamarins are reared primarily by the males.

COMMON NAME
Emperor tamarin

SCIENTIFIC NAME
Saguinus imperator

CONSERVATION STATUS
Least Concern (LC)

POPULATION
Not estimated

HABITAT
Primarily rainforests and Amazonian valleys

SIZE / WEIGHT
⇨ 9–10 in. (23–25 cm)
⚖ 16 oz. (460 g)

GESTATION PERIOD
140–145 days

DIET
Fruit, flowers, nectar, insects, snails, small rodents / lizards / birds

LIFE SPAN
15–20 years

129

RAILA THE PLAINS ZEBRA

DID YOU KNOW...

The zebra's most distinctive feature has to be its black coat with the white stripes. This pattern is as unique as a human fingerprint, and serves both to repel insects and to act as camouflage against the zebra's natural enemies (such as lions, which are colorblind). Zebras live in families, each comprising a stallion, multiple mares, and their foals. These families often intermingle with herds of gnus or other antelope species. Teamwork is highly prized among zebras. Sometimes, rather than fleeing an attacker—which they do in zigzag patterns at maximum speeds of up to 40 mph (65 km/h)—a group of zebras will form a semicircle, ready to use their hooves to defend themselves if necessary. Zebras sleep standing up, often resting their heads on each other's necks for stability. They are threatened by habitat reduction caused by livestock farming, and by having to compete with other animals for water. A subspecies of the plains zebra, the Quagga, has already died out.

COMMON NAME
Plains zebra

SCIENTIFIC NAME
Equus quagga

CONSERVATION STATUS
Nearly Threatened (NT)

POPULATION
500,000 individuals

HABITAT
Plains and savanna

SIZE / WEIGHT
⇧ 3.6–4.8 ft. (1.1–1.45 m)
⇨ 7.1–8.1 ft. (2.17–2.46 m)
🏋 386–849 lb. (175–385 kg)

GESTATION PERIOD
360–369 days

DIET
Grasses

LIFE SPAN
25 years

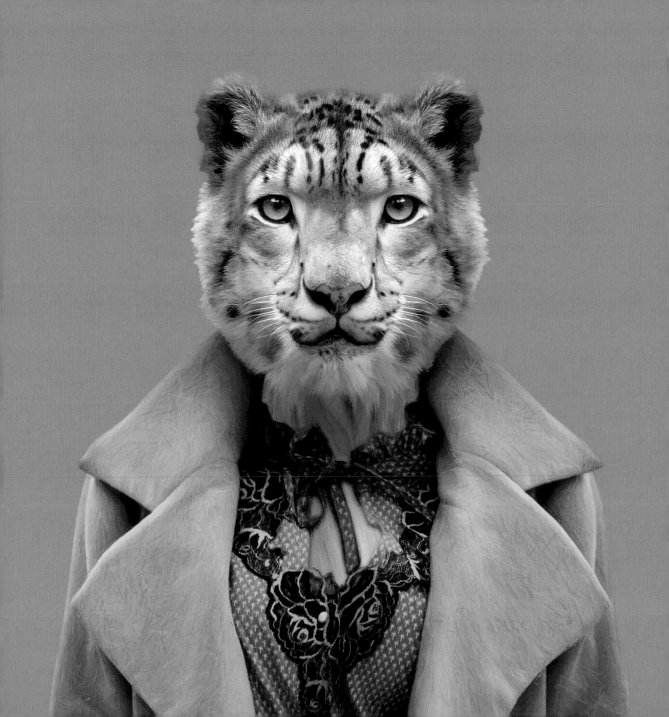

AIPERI THE SNOW LEOPARD

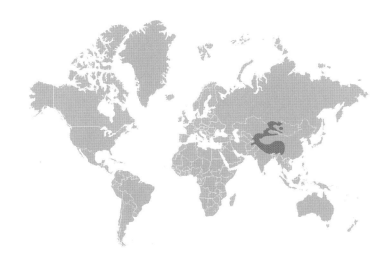

COMMON NAME
Snow leopard

SCIENTIFIC NAME
Panthera uncia

CONSERVATION STATUS
Endangered (EN)

POPULATION
4,080–6,590 individuals

HABITAT
Steep, remote mountainous regions
with snow up to 19,685 ft. (6,000 m)

SIZE / WEIGHT
⇧　2 ft. (0.6 m)
⇨　14.3 ft (1.3 m)
⬛　60–121 lb. (27–55 kg)

GESTATION PERIOD
93–110 days

DIET
Hares, squirrels, goats, game, birds,
choughs, tahrs, shrews, marmots,
ibexes, markhors

LIFE SPAN
10–12 years in the wild

DID YOU KNOW...

With a body length from about 30 in. to a maximum 60 in. (75–150 cm), snow leopards can be considered smaller versions of big cats. They use their striking tails, which are long, plush, and about three-quarters of the length of their bodies, as extra protection against the cold by wrapping them around their bodies when they curl up into a ball at night. Snow leopards live in areas with high, rocky cliffs, which they negotiate well as hunters, thanks to their ability to jump up to vertically to a height of 49.2 ft. (15 m) can jump up to 15 meters with a single leap. Their light gray coats, which are sprinkled with black spots, create excellent camouflage as they hunt, which they do not need to do every day because they store the carcasses of their prey in tunnels in the snow and feed on them for multiple days. Females hide their litters (two to five cubs) in rock crevices, and the kittens stay with their mothers until they have learned to hunt on their own, at about two years old. Many adolescents do not reach this age, however, due to a shortage of prey animals. Incidentally, expert opinion is divided as to whether or not snow leopards can actually roar.

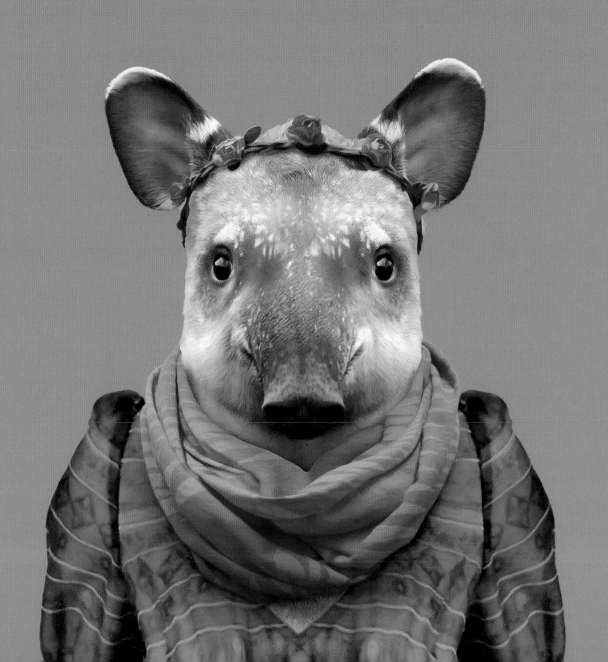

GABRIELA THE SOUTH AMERICAN TAPIR

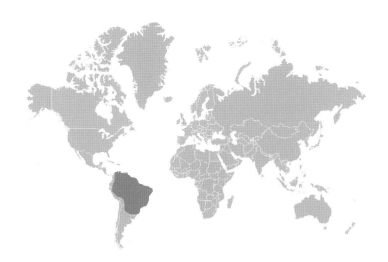

COMMON NAME
South American tapir / Brazilian tapir / Lowland tapir

SCIENTIFIC NAME
Tapirus terrestris

CONSERVATION STATUS
Vulnerable (VU)

POPULATION
Not estimated, but declining

HABITAT
Rainforests, riparian areas, swamps

SIZE / WEIGHT
⇧ 3.3 ft. (1 m)
⇨ 5.9–8.2 ft. (1.8–2.5 m)
⚖ 330–710 lb. (150–320 kg)

GESTATION PERIOD
383 days

DIET
Mostly leaves, twigs, aquatic plants, and fruit

LIFE SPAN
25–30 years

DID YOU KNOW...

Although tapirs are quite pig-like in appearance, their closest relatives are actually rhinos and horses. They are characterized by their relatively short, but very mobile snouts, which they use both for drinking and for plucking twigs, leaves, fruits, and other foods, and placing them into their mouths. These snouts are also outstanding for ripping out aquatic plants. Tapirs, which are nocturnal and can weigh over 660 lb. (300 kg), tend to live near water. Although they can also run relatively fast on land, they are, first and foremost, excellent swimmers. When fleeing predators, they immediately head for water, where they dive under as quickly as possible. The tapir's gestation period is thirteen to fourteen months. Most mothers produce just one calf at a time, which remains by her side until it is fully grown, at around eighteen months. Until they are approximately six months old, young tapirs have white stripes on their fur, which help to camouflage them. Incidentally, tapirs can be considered "living fossils," since their species has persisted almost unchanged for over 55 million years.

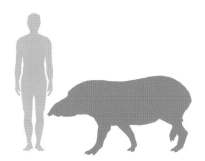

ATOM THE CHIHUAHUA

DID YOU KNOW...

At a maximum 9 in. (23 cm) tall, this, the world's smallest dog breed, gets its name from the town in which it was discovered: Chihuahua, Mexico. Officially, these small dogs are called Chihuahueño. Despite their small stature, Chihuahuas have a lively temperament and are remarkably brave when they feel threatened. They do not get along well with other dogs, however. There are both long-haired and short-haired varieties of Chihuahuas, with many different color combinations. These small dogs have large heads compared to the size of their bodies, with large eyes, large, erect ears, and short muzzles. As with other dogs, their sense of smell is 100,000 times more sensitive than that of humans, and their wet noses allow them to detect airborne scents very easily. Chihuahuas became very popular in the United States when one of them starred in a TV advertisement for the Taco Bell fast food chain.

COMMON NAME
Chihuahua

SCIENTIFIC NAME
Canis lupus familiaris

CONSERVATION STATUS
Not Evaluated (NE)

POPULATION
Common

HABITAT
Domestic animal (pet)

SIZE / WEIGHT
⇧ 6–9 in. (15.2–22.9 cm)
⚖ 3.3–6.6 lb. (1.5–3 kg)

GESTATION PERIOD
58–65 days

DIET
Biologically carnivorous,
but omnivorous as pets

LIFE SPAN
10–18 years

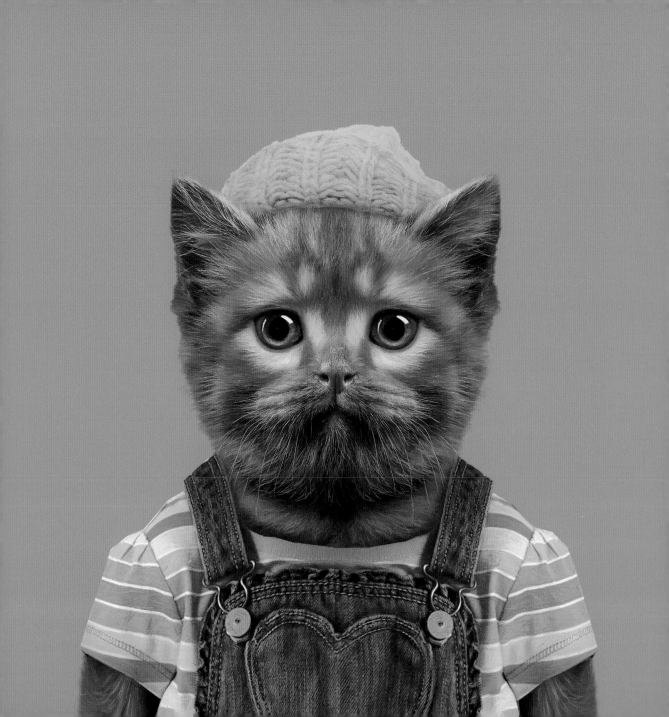

ABBY THE BRITISH SHORTHAIR CAT

DID YOU KNOW...

The most popular color for this cat breed is blue-gray (British Blue), but the British Shorthair comes in many color variations. Since, like all cats, British Shorthairs hunt even when they are not hungry, they were initially raised to control household pests. However, their great success at cat shows resulted in increasingly extensive breeding programs. At the start of the 20th century, however, when long-haired Persian cats came into fashion, the British Shorthair was bred much less often, and the destruction caused by World War II nearly resulted in their extinction. Following the war, however, a new breeding program was started in Great Britain, which made this breed more robust, with a rounder head and brighter eyes. British Shorthairs are excellent hunters, but are also very affectionate cats with easygoing personalities who love nothing more than to be petted. Like all cats, they spend two-thirds of the day sleeping and one-third of the remaining time grooming themselves, and sweat only through their feet.

COMMON NAME
British Shorthair cat

SCIENTIFIC NAME
Felis silvestris catus

CONSERVATION STATUS
Not Evaluated (NE)

POPULATION
Very common

HABITAT
Domestic animal (pet)

SIZE / WEIGHT
⇨ 14–20 in. (35–50 cm)
🏋 12–18 lb. (5.5–8 kg)

GESTATION PERIOD
64–67 days

DIET
Historically birds, mice, and lizards, but cat food as pets

LIFE SPAN
13 years

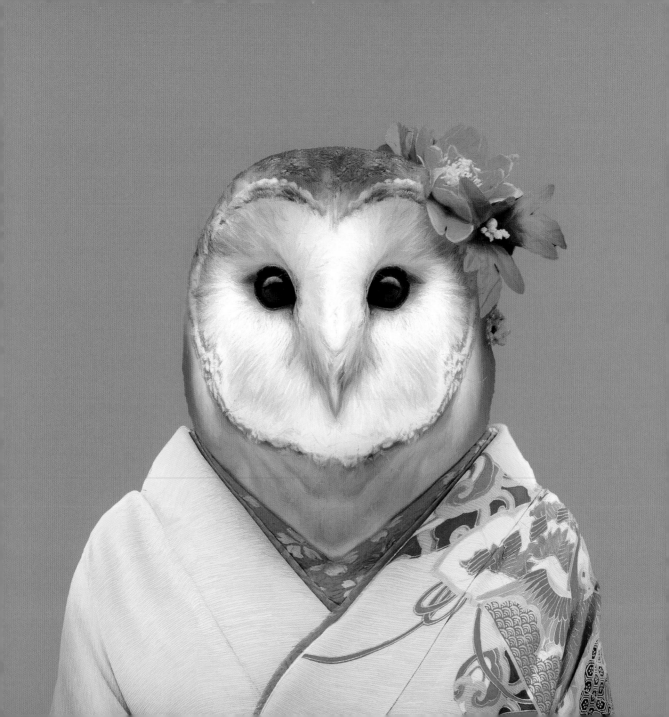

ISABELLA THE BARN OWL

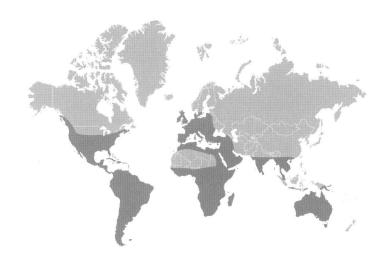

DID YOU KNOW...

There are over 40 species of barn owl, which are distributed over almost the entire world. Female barn owls tend to have more reddish, more heavily spotted chest feathers. Not only do these spots have parasite-repelling capabilities, but they also serve to attract males. Owls have excellent hearing, enabling them to locate their prey (rodents) from great distances, while their heart-shaped facial plumage serves as a kind of parabolic antenna to focus sounds. They themselves are almost silent in flight and have outstanding night vision. An owl eats around 5,000 prey animals per year, swallowing them skin, bones, and all. As many rodents contain rat poison, which causes death by overdose in some (but not all) animals, rat poison is found in the bodies of many owls. On average, owls hatch two to three chicks per year, but not all owl pairs breed.

COMMON NAME
Barn owl

SCIENTIFIC NAME
Tyto alba

CONSERVATION STATUS
Least Concern (LC)

POPULATION
9,200,000 individuals

HABITAT
Close to humans, in open areas with scattered trees

SIZE / WEIGHT
⇑ 13–15 in. (33–39 cm)
⚖ 7.9–25 oz. (224–710 g)

BROODING PERIOD
29–34 days

DIET
Mainly small rodents, but also small birds, insects, amphibians, and reptiles

LIFE SPAN
15–23 years

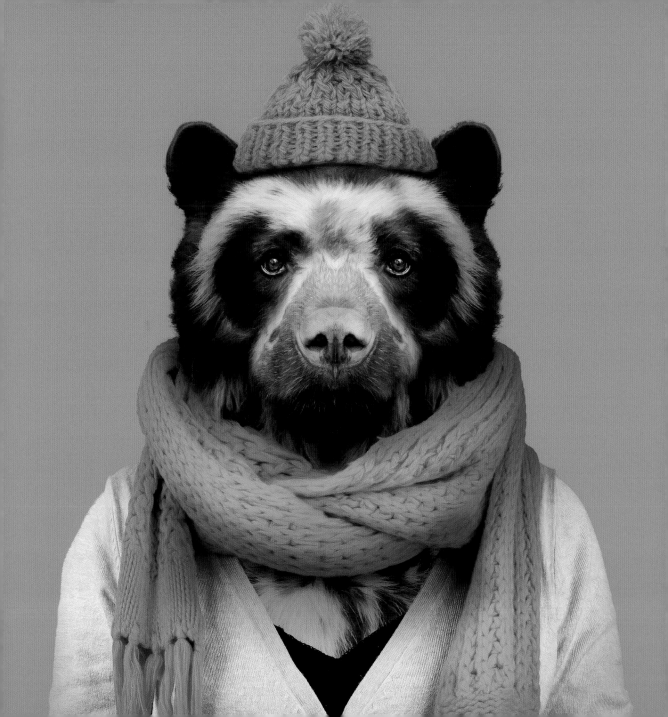

ANA MARIA THE SPECTACLED BEAR

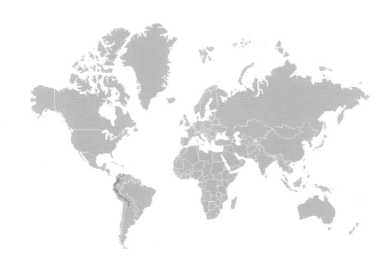

COMMON NAME
Spectacled bear or Andean bear

SCIENTIFIC NAME
Tremarctos ornatus

CONSERVATION STATUS
Vulnerable (VU)

POPULATION
18,250 individuals in 2004

HABITAT
Humid forests in the Andes Mountains

SIZE / WEIGHT
⇧ 2.3–3 ft. (0.7–0.9 m)
⇨ 3.9–6.6 ft. (1.2–2 m)
⚖ ♀ 132–195 lb. (60–80 kg)
⚖ ♂ 220–386 lb. (100–175 kg)

GESTATION PERIOD
165–255 days (delayed implantation)

DIET
Mainly plants and fruit; occasionally rodents, birds, and carrion

LIFE SPAN
Up to 25 years

DID YOU KNOW...

These unique bears, which originate in South America (primarily Peru), differ from other bears in one important trait: their cells contain only 52 chromosomes, instead of the 74 of other bears. Additionally, these bears only have 13 pairs of ribs, instead of the usual 14. These facts lead experts to conclude that spectacled bears were isolated 12 million years ago. Due to the mild temperatures of their habitat, their skin is thinner than that of other bears, and they do not hibernate like polar bears, brown bears, or black bears. They live in remote areas and traditionally have had little contact with people. For a long time, these bears were considered mythical creatures, deeply woven into the culture of the Andes. Although they symbolize protection in this culture, their population is being decimated primarily by local farmers and ranchers, who fear a loss of livestock or crops. Natural enemies of the spectacled bear include pumas and jaguars. Spectacled bears can use their large claws to scale cliffs and climb trees, where they build nests to sleep and to raise their young. They also use them as places to collect fruits and berries from the same trees.

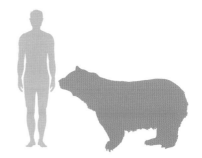

FRITZ THE LONG-EARED HEDGEHOG

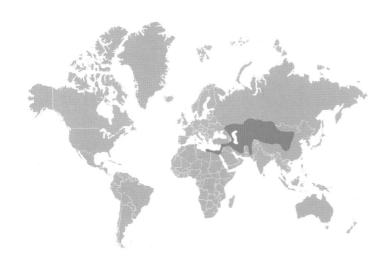

DID YOU KNOW...

Long-eared hedgehogs are somewhat smaller than common hedgehogs, but they can run much faster. Just like all hedgehogs, their bodies are protected by a thick layer of brown spines with white tips. A long-eared hedgehog searching for food can travel as far as 5.6 miles (9 km) in one night. A hedgehog burrow houses only one hedgehog, and mothers expand their burrows only for their young. Mating season happens once each year, between July and September, and the hedgehogs' spines do not inhibit their ability to reproduce. The spines of newborn hedgehogs are initially still embedded in their skin, but poke through the skin in their first 5 hours of life. Long-eared hedgehogs can survive up to 10 weeks without water or solid food. They use this ability not only to withstand the cold winter months, but sometimes even to beat the heat in the summer months with a type of summer hibernation. During this time, their pulse rate drops from 190 beats per minute to 20 beats per minute.

COMMON NAME
Long-eared hedgehog

SCIENTIFIC NAME
Hemiechinus auritus

CONSERVATION STATUS
Least Concern (LC)

POPULATION
Common

HABITAT
Dry steppes, semideserts, deserts

SIZE / WEIGHT
⇨ 4.7–10.6 in. (12–27 cm)
⬛ 14–17.6 oz. (400–500 g)

GESTATION PERIOD
35–42 days

DIET
Insects, small vertebrates, eggs, fruit, seeds, carrion

LIFE SPAN
9 years

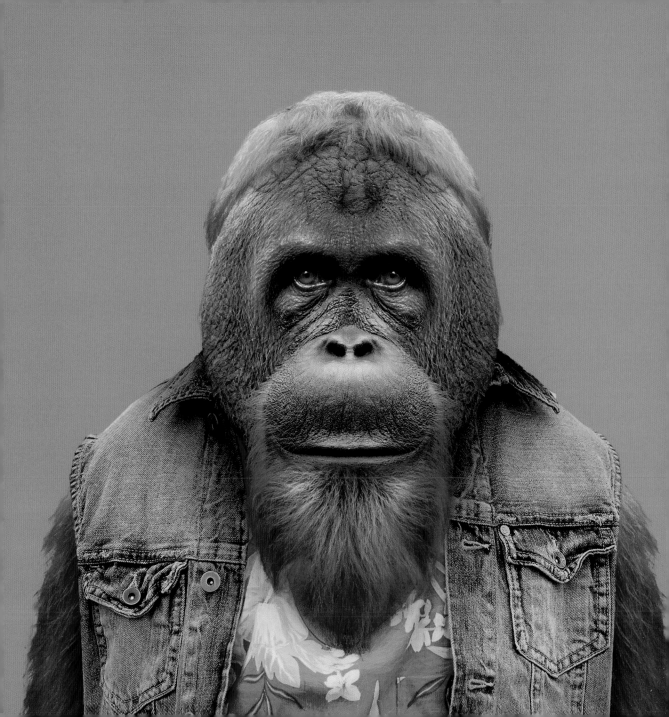

YUSUF THE BORNEAN ORANGUTAN

DID YOU KNOW...

Orangutans are the world's largest (almost exclusively) tree-dwelling mammals. Their hands and feet, all of which have fingers and opposable thumbs, are ideally suited for climbing trees, but are not well designed for moving around on the ground. Male orangutans are considerably larger than females, can produce threatening roars from their throat sacs, and have pads of fat, known as flanges, on their cheeks, the size of which is also considered a symbol of dominance among their fellow males. In contrast to other apes, orangutans tend to be solitary. Female orangutans give birth only once every eight years, a unique occurrence in the animal kingdom, and one that complicates efforts to conserve them. The mother and child relationship in this extremely intelligent species is the most intense of all mammals, with the exception of humans. Young orangutans spend their first five years living in close physical proximity to their mothers, by whom they are nursed for up to seven years. Orangutans are severely threatened by the expansion of plantations, which are swallowing up increasingly large portions of the rainforest.

COMMON NAME
Bornean orangutan

SCIENTIFIC NAME
Pongo pygmaeus

CONSERVATION STATUS
Critically Endangered (CR)

POPULATION
104,000 individuals

HABITAT
Tropical rainforest valleys, swamps, mountain forests

SIZE / WEIGHT
⇨ ♀ 3.3–3.9 ft. (1–1.2 m)
⇨ ♂ 3.9–4.6 ft. (1.2–1.4 m)
🏋 ♀ 66–110 lb. (30–50 kg)
🏋 ♂ 110–220 lb. (50–100 kg)

GESTATION PERIOD
230–275 days

DIET
400+ foods, including fruit, leaves, eggs, flowers, honey, insects, bark

LIFE SPAN
35–45 years

ZOO PORTRAITS
GALLERY

Capra aegagrus hircus

Phoca vitulina

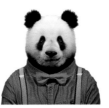

Ailuropoda melanoleuca

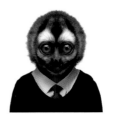

Aotus miconax

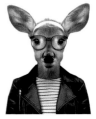

Odocoileus virginianus

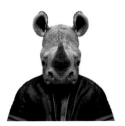

Ceratotherium simum

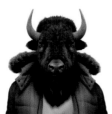

Bos bison

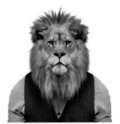

Panthera leo

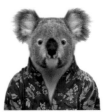

Phascolarctos cinereus

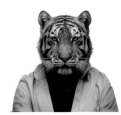

Panthera tigris tigris

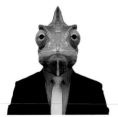

Chamaeleo calyptratus

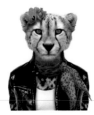

Acinonyx jubatus

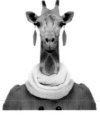

Giraffa camelopardalis

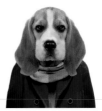

Canis lupus familiaris

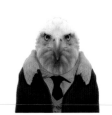

Haliaeetus leucocephalus

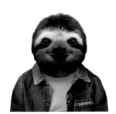

Bradypus variegatus

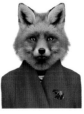

Vulpes vulpes

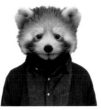

Ailurus fulgens

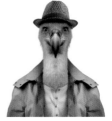

Gyps fulvus

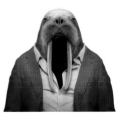

Odobenus rosmarus

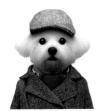

Canis familiaris
maelitacus

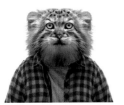

Otocolobus manul

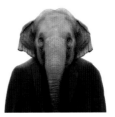

Sarcophilus harrisii

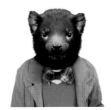

Elephas maximus

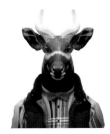

Tragelaphus eurycerus

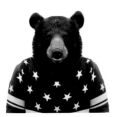

Ursus americanus

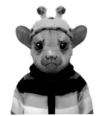

Potos flavus

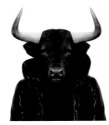

Bos taurus ibéricus

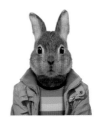

Oryctolagus cuniculus

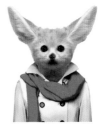

Vulpes zerda

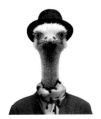

Struthio camelus

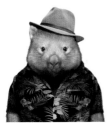

Vombatus ursinus

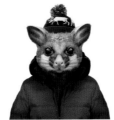

Trichosurus vulpecula

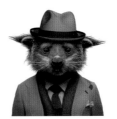

Arctictis binturong

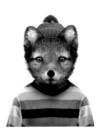

Vulpes lagopus

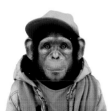

Pan troglodytes

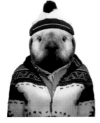

Enhydra lutris

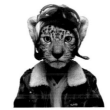

Panthera pardus orientalis

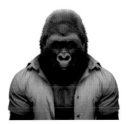

Gorilla gorilla gorilla

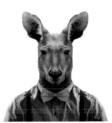

Macropus rufus

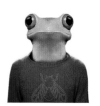

Agalychnis callidryas

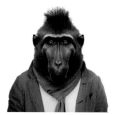

Macaca nigra

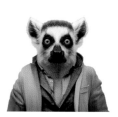

Lemur catta

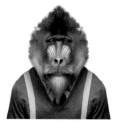

Mandrillus sphinx

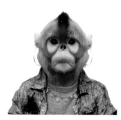

Rhinopithecus roxellana

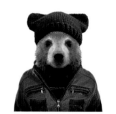

Ursus arctos middendorffi

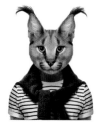

Caracal caracal

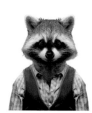

Procyon lotor

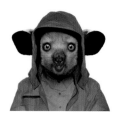

Daubentonia
madagascariensis

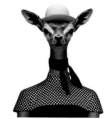

Litocranius walleri

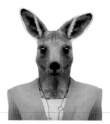

Macropus giganteus

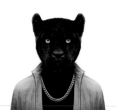

Panthera pardus /
Panthera onca

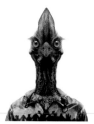

Casuarius casuarius

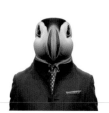

Fratercula arctica

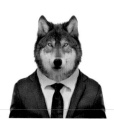

Canis lupus

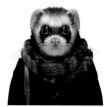

Mustela putorius furo

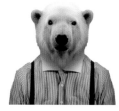

Ursus maritimus

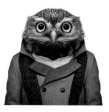

Athene noctua

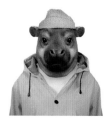

Choeropsis liberiensis

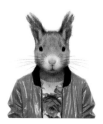

Sciurus vulgaris

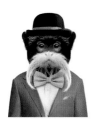

Saguinus imperator

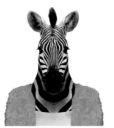

Equus quagga

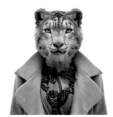

Panthera uncia

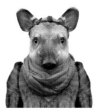

Tapirus terrestris

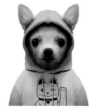

Canis lupus familiaris

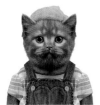

Felis silvestris catus

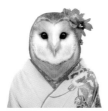

Tyto alba

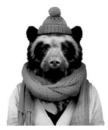

Tremarctos ornatus

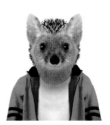

Hemiechinus auritus

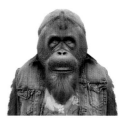

Pongo pygmaeus

YAGO PARTAL studied visual arts at the University of Barcelona. One of his creative projects gave him the inspiration for Zoo Potraits. With his enthusiasm for animals, cartoons, and fashion, he began experimenting with the popular anthropomorphization of animals; the result was a cosmos of unique artworks. Yago Partal's work has been the subject of exhibitions in London, Tokyo, Montreal, Tainan and Barcelona among others. His customers include world-renowned companies such as Apple and Body Shop.

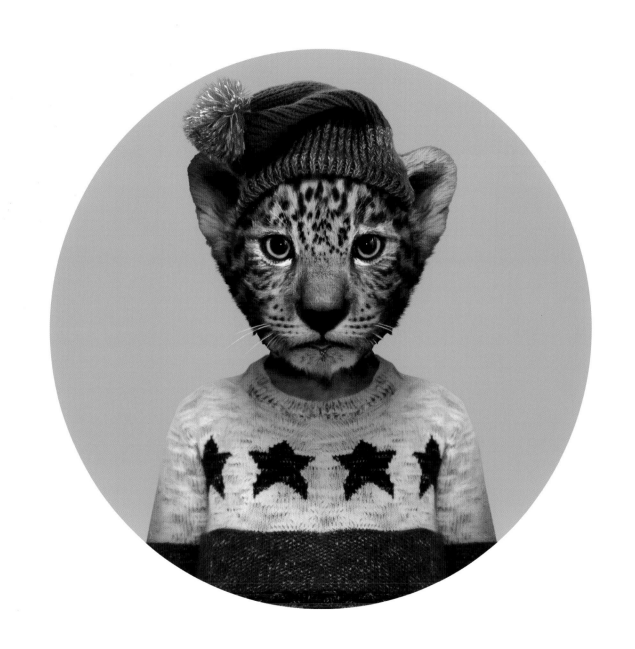

IMPRINT ZOO PORTRAITS

Creative Director | Martin Graf
Graphic Design | Anika Lethen
Animal silhouettes | © Susanne Kuhlendahl
Editorial coordination: Stephanie Rebel
Text | Stephanie Bräuer
Translation & copyediting | Jodette Kruger,
Hilary Davies Shelby
Production | Sandra Jansen-Dorn, Alwine Krebber
Image processing and proofing | Jens Grundei

Published by teNeues Publishing Group
teNeues Media GmbH & Co. KG
Am Selder 37, 47906 Kempen, Germany
Phone: +49-(0)2152-916-0
Fax: +49-(0)2152-916-111
e-mail: books@teneues.com

teNeues Media GmbH & Co. KG
Pilotystraße 4 | D-80538 München
Phone: +49(0)89-443-8889-62

Press department: Andrea Rehn
Phone: +49-(0)2152-916-202
e-mail: arehn@teneues.com

teNeues Publishing Company
350 Seventh Avenue, Suite 301, New York, NY 10001, USA
Phone: +1-212-627-9090 Fax: +1-212-627-9511

teNeues Publishing UK Ltd.
12 Ferndene Road, London SE24 0AQ, UK
Phone: +44-(0)20-3542-8997
teNeues France S.A.R.L.

39, rue des Billets, 18250 Henrichemont, France
Phone: +33-(0)2-4826-9348
Fax: +33-(0)1-7072-3482

www.teneues.com
ISBN 978-3-96171-046-1

Library of Congress Number | 2017942051
Printed in the Czech Republic

The Deutsche Nationalbibliothek lists this publication in
the Deutsche Nationalbibliografie; detailed bibliographic
data are available on the Internet at http://dnb.dnb.de

teNeues Publishing Group
Kempen
Berlin
London
Munich
New York
Paris

FSC
MIX
Papier aus ver-
antwortungsvollen
Quellen
Paper from
responsible sources
FSC® C005833